Contents

SO-AIV-370

Preface

In my long lifetime as an artist trees have, perhaps, been my first love. They figure prominently in the paintings I have done and in the books I have written. None of these books is available any longer and in this new volume I have drawn upon much material both in text and illustration which had appeared previously, though in a somewhat different form. I would like to express my thanks to my publishers, and particularly to Miss Geraldine Christy, who has helped me so patiently with the compilation of this book.

The coloured illustrations of tree studies, which appear to be rather isolated from their natural settings, are included to help the tree lover in identification rather than to show examples to the student artist of the part to be played by trees in a finished composition. I hope I have been able to show through the black and white illustrations and the text some of the varied ways of handling trees that make them so essential a feature to the landscape painter.

A.H.

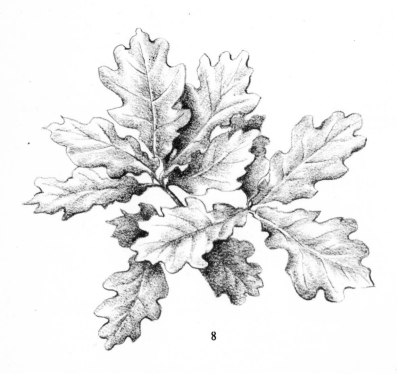

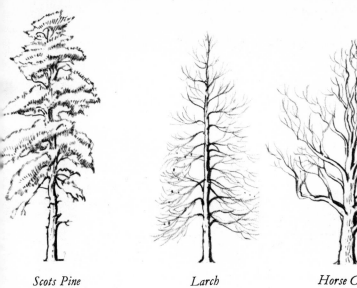

Scots Pine

Larch

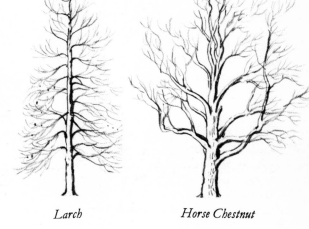

Horse Chestnut

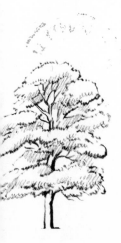

Sycamore

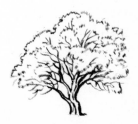

Hawthorn

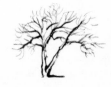

Apple

Trees are an essential part of most pictures,
whether of the rural scene, the garden
or the wider, perhaps rugged, landscape.
Yet it is in the drawing of trees
that the amateur artist so often flounders.
An understanding of trees and
their shapes, and how to paint them,
both individually and as part of a
composition, is essential for the novice
and for the serious artist of every
age group.

Adrian Hill writes with an enthusiasm
which demonstrates rather than expounds.
He leads the reader through all
stages of tree illustration, from
fundamental tree appreciation,
covering the structure of trees,
through individual tree studies, to
the role they play in pictorial
composition.

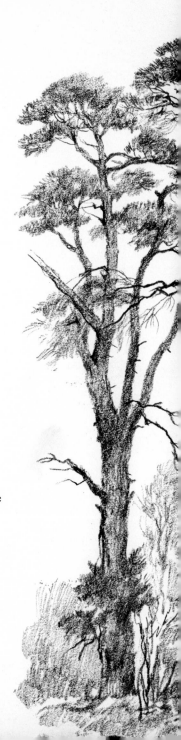

By the same author

Drawing and Painting Architecture in Landscape
Faces and Figures
Drawing and Painting Flowers
How to Paint Landscapes and Seascapes
The Beginner's Book of Oil Painting
Further Steps in Oil Painting
Sketching and Painting Out of Doors
The Beginner's Book of Watercolour Painting
What Shall We Draw?
Further Steps in Drawing and Sketching

Drawing and Painting Trees

written and illustrated by
ADRIAN HILL
P.P.R.O.I., R.B.A.

BLANDFORD PRESS
POOLE DORSET

First published in 1977 by Blandford Press Ltd,
Link House, West Street,
Poole, Dorset.
BH15 1LL
Copyright © Blandford Press 1977

ISBN 0 7137 0835 2

Printed in Great Britain
by Butler & Tanner Ltd,
Frome and London

I Introduction

To the landscape artist trees are irresistible and indispensable to picture making; all types are potential grist to the mill. Whether in youth or maturity, tall or short, graceful or grotesque, green or 'dry', alive or 'dead', trees are and will remain Nature's greatest gift to the painter (despite the fact that one is often ignorant of the very names of the gratuitous subjects.)

The constant plaint with which the instructor is assailed is, 'How do you *do* trees, or trunks, or foliage?' Students believe that the magic 'How-to-do-it' ace is up his sleeve, and that he will show them how to play it in his own good time.

Some excuse can be made on the student's behalf, however, for there is nothing so ruthless as the painting of trees in compelling you to realize your technical shortcomings. If you are weak in drawing, that weakness shows up immediately; if you are uncertain on colour, your tints will certainly be too green; and unless you have acquired a confident rendering of vegetation, your foliage will be either spotty or opaque.

As the result of a fairly wide experience I have come to the conclusion that the average student who, after a few tentative efforts, abandons the practice of tree painting for some other branch of art which promises larger aesthetic profits and quicker returns, is actuated by the difficulties that seem to come to meet him more than half way.

Indeed most of the writers on art have been affected by a not-unnatural reserve when it comes to imparting practical instruction. They all agree that the student is liable to fall into innumerable errors; but, for the avoidance of them, they subscribe to the dictum that it is 'absolutely necessary that an artist must not only study tree form, but must also learn something of their habits and requirements'. They are generally more informative about the trees themselves than about the manner in which they should be drawn and painted.

Many students leap to the premature conclusion that they 'simply cannot do trees'. But it is only by diligent concentration upon the form of trees when drawing them, that a sense of their construction is vouchsafed; in the study of shape and size the secrets of life and growth are learnt.

The approach to competence in tree painting must be by way of drawing, composition, and tone, plus colour, plus technique. These are all essential, and should be mastered in the order named.

2 *Tree Appreciation*

It is obviously very little good attempting to paint a tree in full leaf until we have examined the structure that the foliage is concealing and are familiar with the body that lies beneath the folds of the dress.

For the purpose of general comparison a tree in winter may be likened to the human form, in that it is composed of a main trunk furnished with limbs, or branches. In both cases the limbs are *cylindrical* in form; but, while the human frame sends out four limbs which spring from the four 'corners' of the trunk, and are practically uniform in length and breadth, each tree produces a different number of branches of unequal length and thickness issuing in all directions and at various intervals from the main stem.

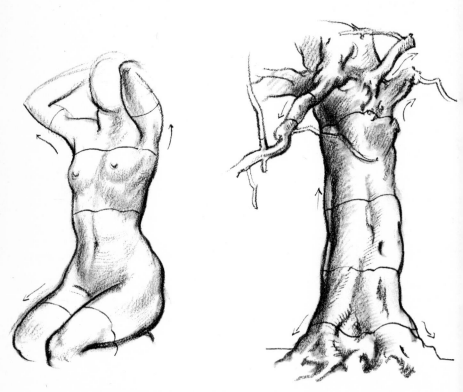

Diagrams demonstrating similarities between the human and tree forms

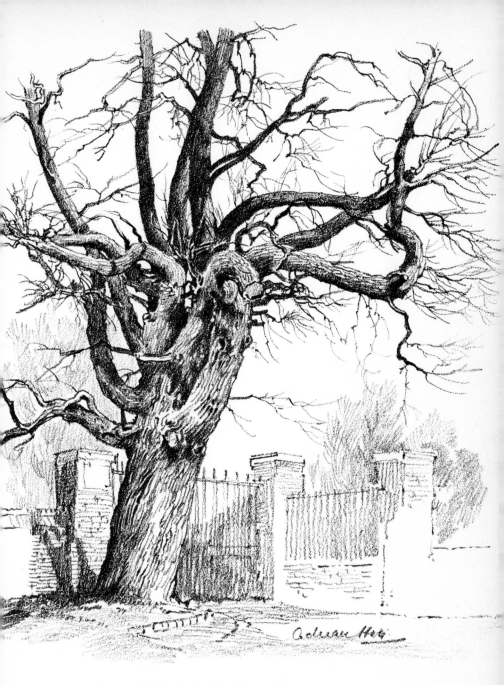

Study of an ancient Chestnut Tree
(*Note the fantastic ramification of the lower boughs.*)

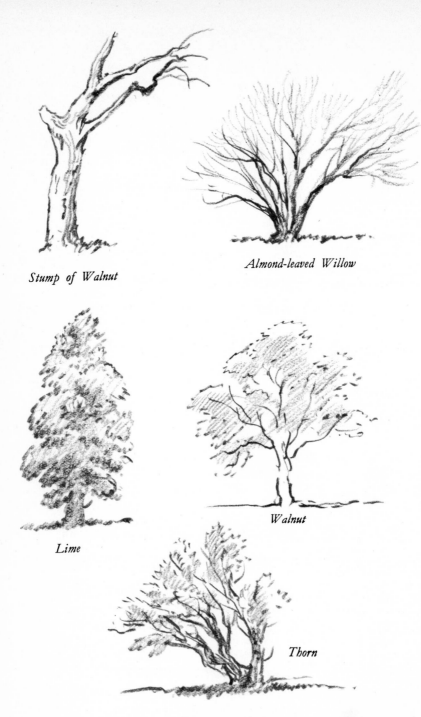

Stump of Walnut

Almond-leaved Willow

Lime

Walnut

Thorn

TREE SHAPES

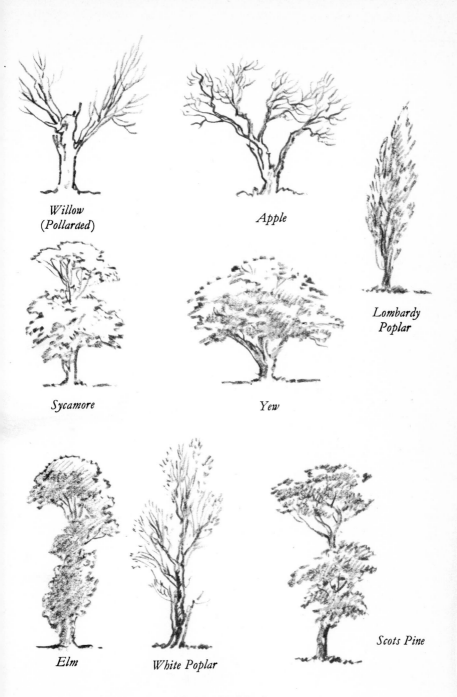

Willow
(Pollarded)

Apple

Lombardy
Poplar

Sycamore

Yew

Elm

White Poplar

Scots Pine

TREE SHAPES

It is really better to begin a study of trees in the winter months when their basic shapes and outlines are visible, for without a sound idea of their fundamental construction no really good drawings can be made. It is like drawing the human figure, where a knowledge of anatomy should precede the stage when you draw the fully clothed figure.

Once this inside information is acquired we must carry it in our minds, or better still in our sketch-books, against the time when tree trunks and branches are almost entirely veiled by their wealth of verdant foliage. A series of such 'references' collected through the year will be found to be of inestimable value to the student when he reaches the stage of tree composition.

Preliminary pencil study of Sycamore

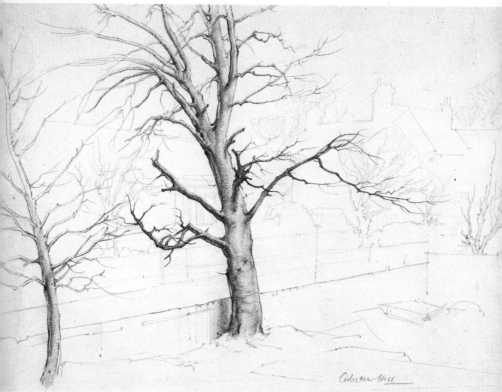

There is a wide range of mediums in which this reference library can be compiled, and our choice may be guided by our personal facility in the use of the various materials and the time that is available for making our drawings. Pencil and chalk are admirable vehicles for quick notation and can be manipulated while standing to work. Pen and ink or pen and wash involve a more protracted proceeding, and indicate a sitting position. The use of oils and watercolours, for which time and settled weather and an accumulation of experience are needed, may be deferred for later consideration.

It often happens that certain trees present peculiarities which seem to demand a special medium, but for the purpose of making drawings in the spring, when stems and branches are almost bare of leaves and their forms are sharply silhouetted against the sky, I do not think that the student can do better than stick to pencil or chalk, and use a sketch-book which is big enough to take careful drawings of an entire tree.

Before starting on the actual work of drawing his tree, the student will find it well worth while to subject his model to a careful preparatory scrutiny from all available angles. The selection of the right point of view is rather more than half the battle. Some trees which are strongly influenced by direction of growth and prevailing wind reveal particularities in form and tone that can be considered only from certain positions, and appear to be entirely destitute of drawable or paintable qualities if approached from any other direction. Again, if the tree is inclining directly towards the spectator, the projection of the boughs and topmost branches is extremely difficult to depict, while from another angle the form may be more attractively revealed as a subject and present a simpler technical problem.

But whichever viewpoint is selected, some boughs must always be pointing towards the artist, and these will be balanced by other branches on the farther side of the tree; and although some may be lost to sight they must be kept in mind. Only those boughs which are responsible for the general shape and formation of the tree need to be set down; for it is usually impossible to draw all the details of the structure, and a process of selection will have to be employed. The greatest use can be made of light and shade in suggesting the recession of both boughs and foliage, and the shadows cast by branches across the bole of the tree should be looked for, as these will be found extremely helpful in breaking the monotony of big areas of bark.

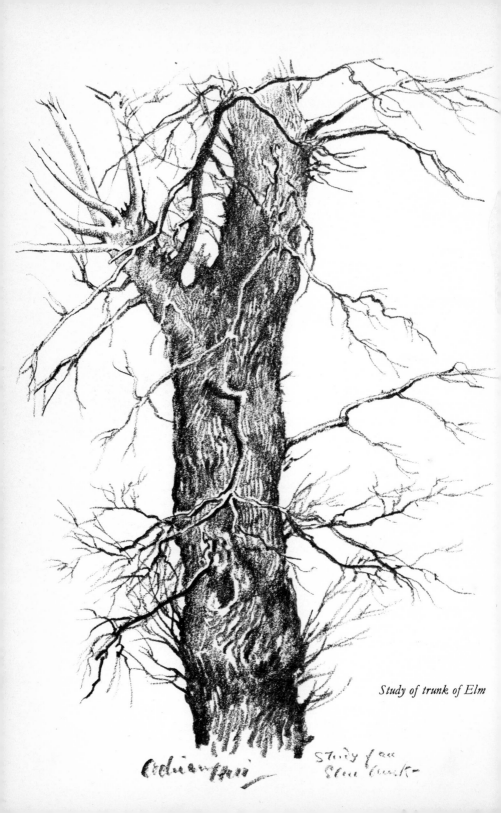

Study of trunk of Elm

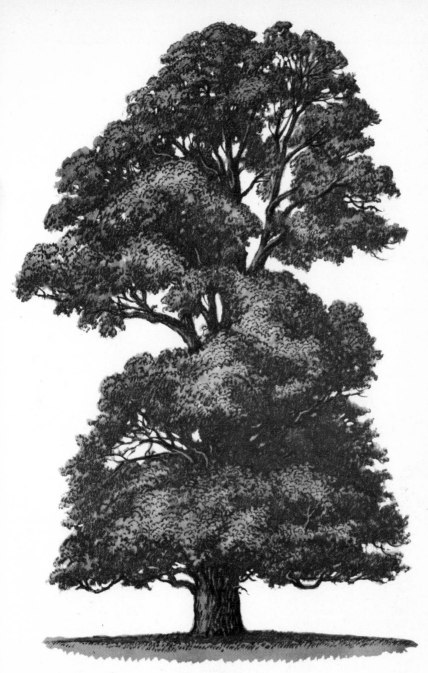

Elm (English)

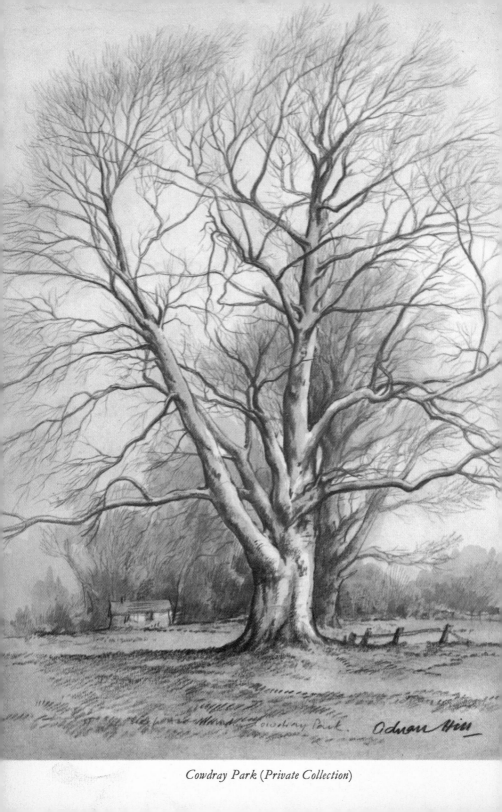

Cowdray Park (Private Collection)

In the works of the majority of students the trees are included without a proper appreciation of their construction and their association with the earth; they appear to rely for support upon their attachment to the background or their neighbours rather than to the ground from which they have sprung. They do not convey the impression of being rooted in the soil, but seem merely placed at a certain spot, and capable of being moved about like pieces on a chessboard.

What the student has to realize is that, just as the branches of a tree radiate from the trunk in all directions, its roots are groping outwards and downwards into the earth, ever intent upon obtaining that purchase upon the soil which is the secret of its stability. With that fact in mind, he will see that the ground at the base of the tree must be considered in relation to its growth and its maintenance of the perpendicular.

The word perpendicular is here used in a very liberal sense; for, with the exception of the Lombardy Poplar and some varieties of Firs, the direction of the stems of most trees deviates in less or greater degree from the upright.

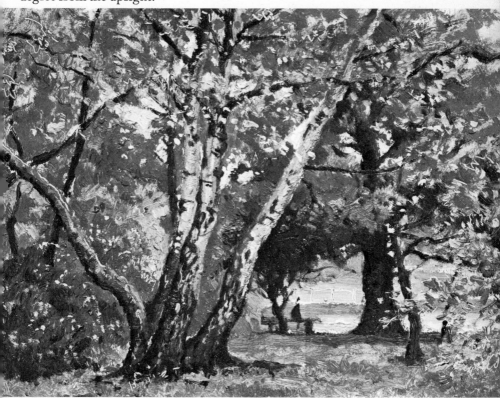

Silver Birches on Hampstead Heath
From the oil painting by the Author (Private Collection)

Are there, then, no laws of the art of portraying trees that may be profitably read, marked, learned, and inwardly digested? There are some, of course, but not many.

One of the immutable laws which Nature herself observes as an artifice in tree construction, and which may be regarded as an axiom by the painter of trees, is that trees do not taper in either the stem, the branch, the bough, or the twig, except and only where they fork. Wherever a trunk sends off a branch, or a branch sends off a lesser branch, or a bough a lesser bough, it diminishes in diameter, and that diameter does not vary by a hair's breadth, until it sends off another bough, branch, or twig. No part of a tree tapers as it proceeds perpendicularly, or horizontally, or at any angle, but diminishes by irregular stages to its extremity.

It has been stated that this law is imperative and without exception, but it would perhaps be more accurate to say that while the tapering is not smooth and uninterrupted like that in the tusk of an elephant, it proceeds by perceptible degrees as in the bone formation in an oxtail. But the tree does not, in effect, taper in the precise meaning of the term.

If Nature can practise this deception upon the unsuspecting artist in the dry tree, what chance has he of detecting the imposition in the case of the green, where the skeleton structure is only visible throughout the foliage at irregular intervals, and then always appears to be tapering to its end?

Parkland, Kent
From the watercolour by the Author (Private Collection)

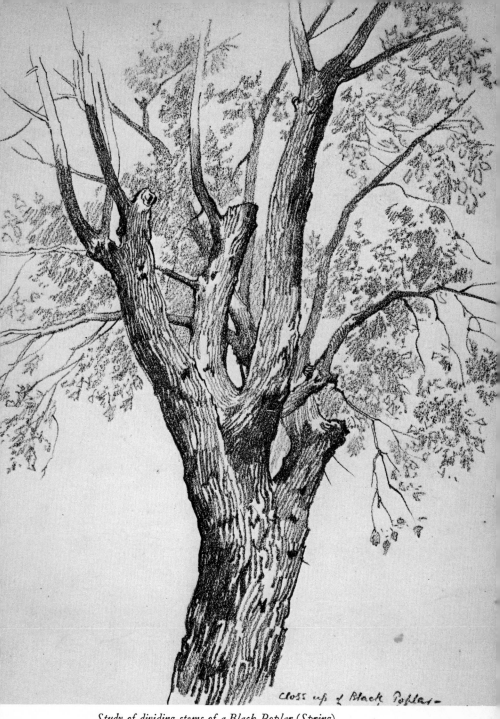

Close up of Black Poplar—

Study of dividing stems of a Black Poplar (Spring)

3 Studies for Tree Drawing

For our first exercise I advise the making of 'close-ups' of the bole, limiting the investigation to the formation of the bark and the fashion of the lower and larger branches. It will suffice if the student sets himself to *copy* as faithfully as possible, the way in which the boughs grow out of the trunk and the manner and direction in which the branches throw out their shoots.

Trees which make admirable models for such studies include the Oak, Beech, Birch, Thorn, Elm, and Ash. In the case of each of the foregoing there is much to record in the distinctive surface of bark, and the characteristic irregularities of the markings.

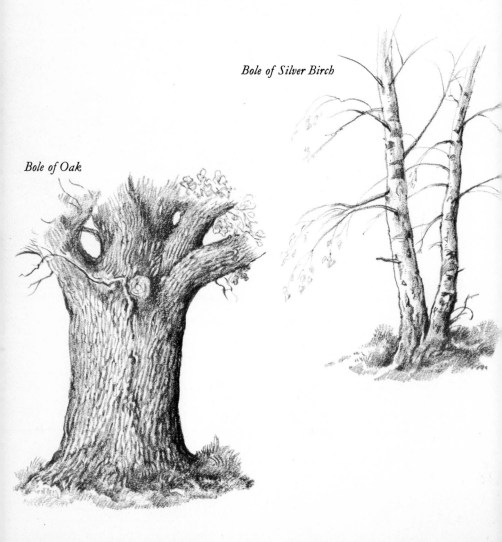

Bole of Silver Birch

Bole of Oak

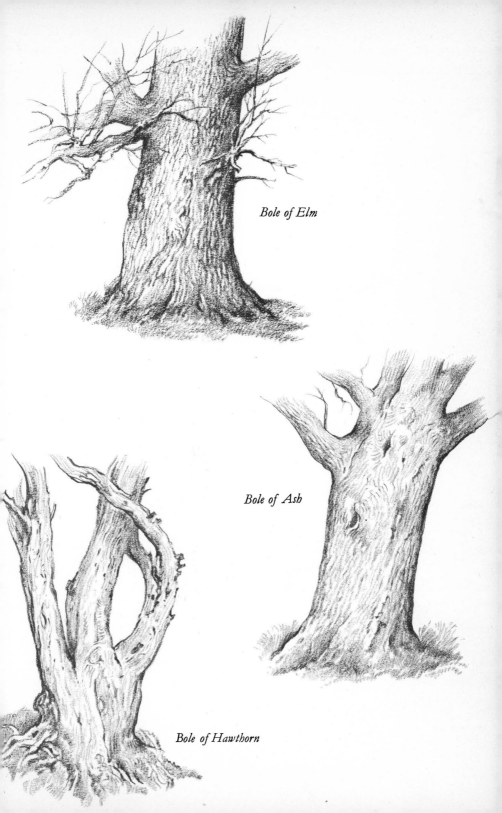

Bole of Elm

Bole of Ash

Bole of Hawthorn

In the case of the Beech, the exposed roots present a fascinating study; for there is something almost human in the conclusive energy with which they twist and turn, like mighty arms, in their efforts to get a better purchase on the earth.

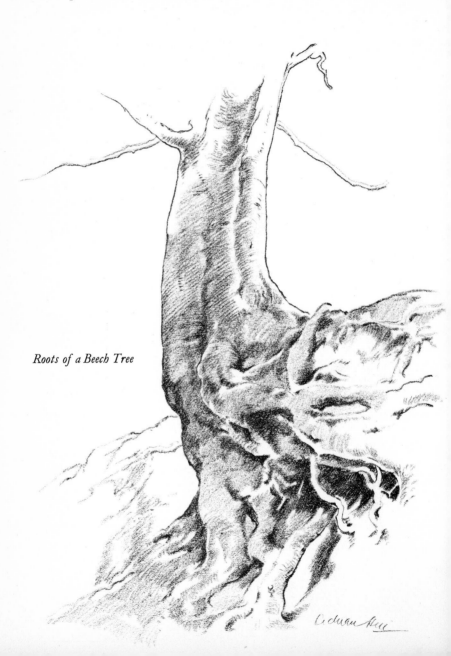

Roots of a Beech Tree

4 *Foliage*

In the eyes of the average person trees seen in summer are brought to a general likeness by reason of the preponderance of a common basic colour. Many artists regard them with the same inefficient vision.

The problem involving in the drawing and painting of foliage falls into two divisions. In the first instance the student has to master the shape of the individual leaves, and in the second he must devise a pattern for representing them in close formation.

Foliage, especially for the beginner in watercolours, will always present difficulties. I would say that even the oversimplified form, where solid green shapes stand duty for leaves in mass, is more satisfactory than the overworked tree in which the leaves are seen as multiple separate details and are conscientiously painted in as such. The compromise is really a matter of touch, which in the practised hand can vary the texture of the painted areas, combining by the use of broad washes of colour for the density of foliage in shadow, with a more flexible and crisp handling where small clusters of leaves catch the light. And, of course, only continual practice and experiment can achieve the desired effect.

I have illustrated a few individual studies of leaves for you on the next few pages.

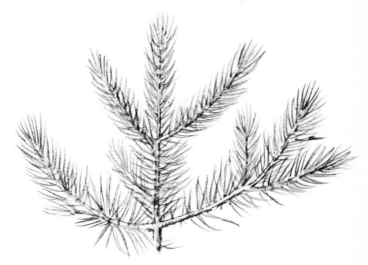

Young leaves of Spruce

23

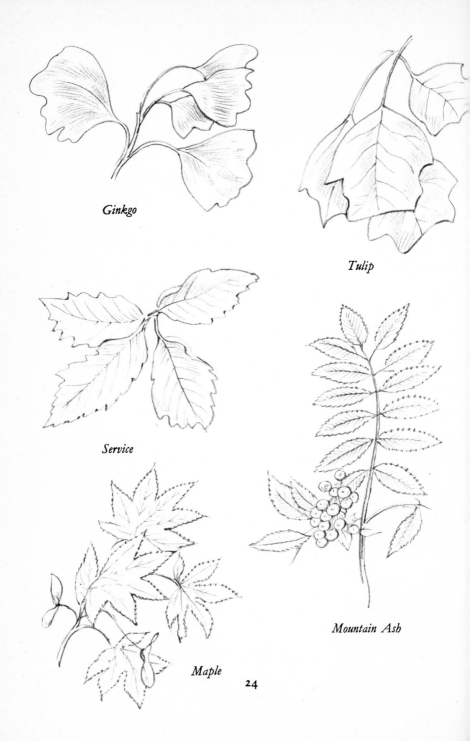

Ginkgo

Tulip

Service

Mountain Ash

Maple

24

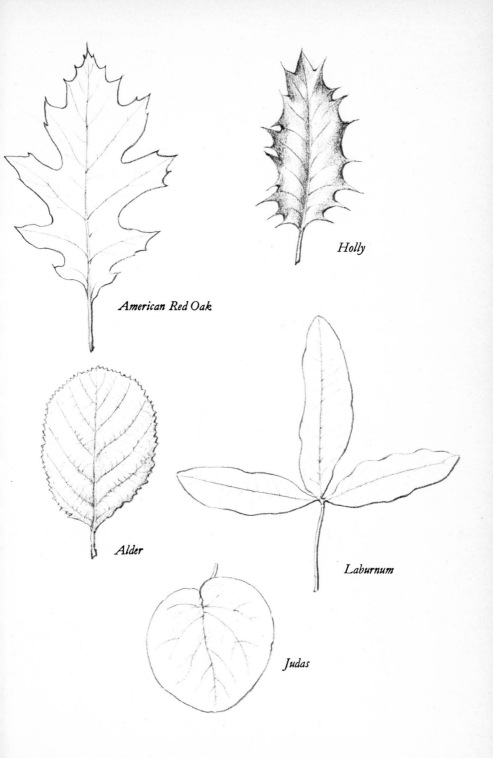

Holly

American Red Oak

Alder

Laburnum

Judas

Foliage of Atlantic Cedar

Spray of Cypress leaves

As I have already stated, facility in depicting trees can be acquired only by assiduous practice. Let me, however, emphasize that necessity by advising the student to make not only repeated drawings, but repeated paintings of the *same tree* taking tracings of his original in the former case and experimenting on these with his technique—following in one the *pattern* made by the branches, not only to the right and left of the trunk, but also of those boughs that come towards him. In another, he should exert his powers to portray the *canopy* of the top-most foliage, and again, to follow the *design* of the supporting branches from which the dependent leaves grow in mass formation.

26

5 *Painting Trees*

If I were asked whether it is easier to paint a tree in monochrome or to paint it in colour, I should decide without hesitation in favour of the latter. But if I am asked which should come first I should reverse my opinion, because there is no finer discipline than the use of monochrome, nor one which will be of such service to the student when he comes to paint with a full palette of oil paints.

Such terms as tone, tint, line, shade, etc., are commonly employed indiscriminately to mean both the same and different things and in using these words it is difficult to convey any precise information without risking the charge of pedantry. If, however, we make our descriptions of these terms as elementary as possible, the truth of their fundamental meanings will be comprehended more readily and be retained longer.

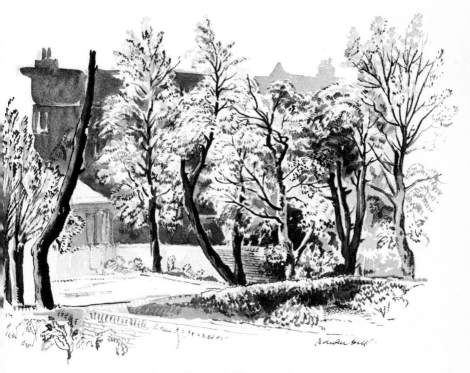

Spring Blossom in Hampstead

Tints are the specific and definite qualities of colours, as distinguishing one from another, such as—Red: Vermilion, Indian Red, etc. Yellow: Yellow Ochre, Lemon Chrome, Cadmium, etc. Blue: Ultramarine, Cerulean, Cobalt.

Tones of colour are the degrees of warmth and coldness, such as cold greens, warm greys. So, there can be lighter and darker shades of the same tone, but not of the same tint. For example, Rose and Crimson may be said to be lighter and darker *shades* of the same *tone*.

If as in monochrome we have one colour only—say, sepia—our darkest tone is the pure colour and the shades are scaled in accordance to our requirements.

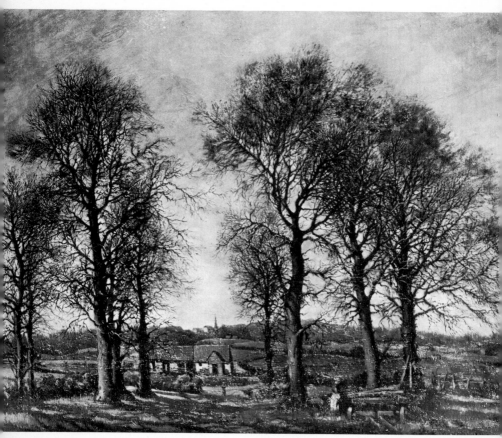

Winter Trees
From the oil painting by the Author (Private Collection)

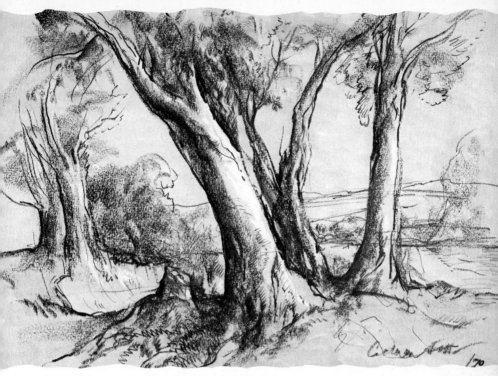

On the banks of the Rother

Painting single trees in monochrome is helpful, in as much as the masses of light and shadow can be worked out. I think in monochrome painting and in painting in watercolours it is better to work from light to dark; so that, when once the lightest portions have been isolated, by leaving these areas as white paper, the student can gradually work down to his darkest portion by adding repeated washes of colour, through the varying degrees of half tone.

In oils, we mix white with the pigment to lighten the tone, and in watercolour we add water.

Crisp touches can be added afterwards, either with a small brush, or in the case of sepia ink (which can be diluted with water) a pen can be used dipped into the pure sepia ink to register the right passages of emphasis. Also, touches of opaque white can supplement those small areas which have become obliterated with previous washes.

In such exercises the drawing of our tree can be retained, and the direction of bark, branch, and leaf can be faithfully followed.

29

I find that wherever I am painting green, a warm ground colour helps to counteract the temptation to get the green of the foliage too cold; and I have discovered that, as all colours tend to dry a lighter key, the light passages upon which this colour has encroached make a satisfactory tone and only need the application of the local tint on top of them. (Let me say here that the dangers of painting too green can be avoided by first putting on a pale wash of yellow ochre, and when it is dry superimposing a faint wash of raw sienna. This will establish tone as well as warmth of colour and on this ground practically any green can be used.)

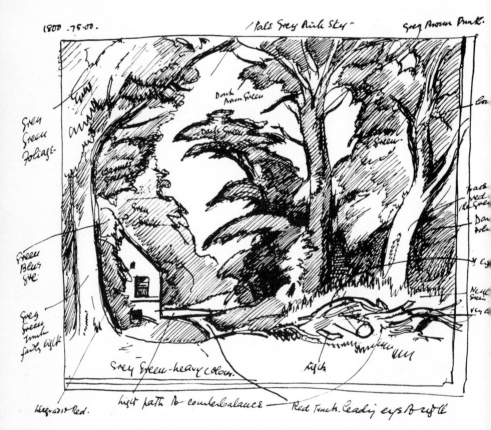

Preliminary pen drawing from the Author's sketch-book

30

6 The Artist's Approach to Individual Trees

THE 'SWEET' OR 'SPANISH' CHESTNUT

As with so many trees, the 'Sweet' or 'Spanish' Chestnut appears to the artist's eyes to improve with age. It is impressive without its leaves as the design of trunk and branches can then be properly appreciated, and are noteworthy in your sketch-book. The closer one approaches the tree, the more wealth of character is revealed, not only in the grand twist of the trunk, but in the tenacious roots and muscular tension of the lower boughs.

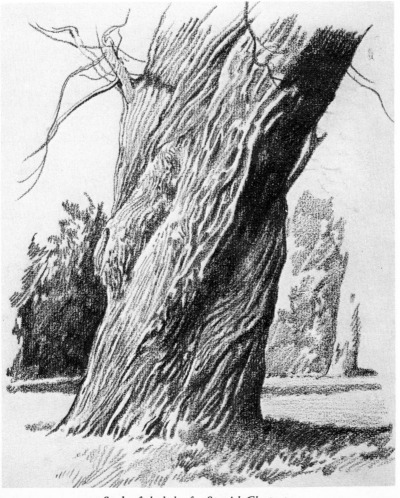

Study of the bole of a Spanish Chestnut

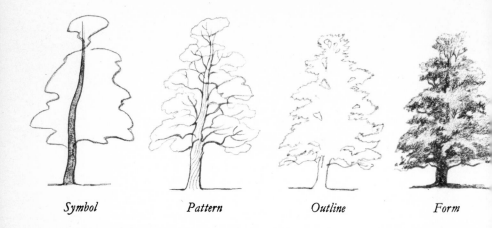

Symbol *Pattern* *Outline* *Form*

The unusual size and length of the leaves in summer suggest a stylized technique of painting, presenting an opportunity for decorative treatment. At a distance, however, and seen, as it were, 'full length' it is not really possible to include such details and they must be surrendered to its fundamental qualities of height and depth.

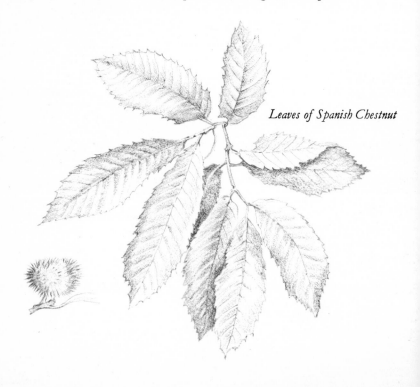

Leaves of Spanish Chestnut

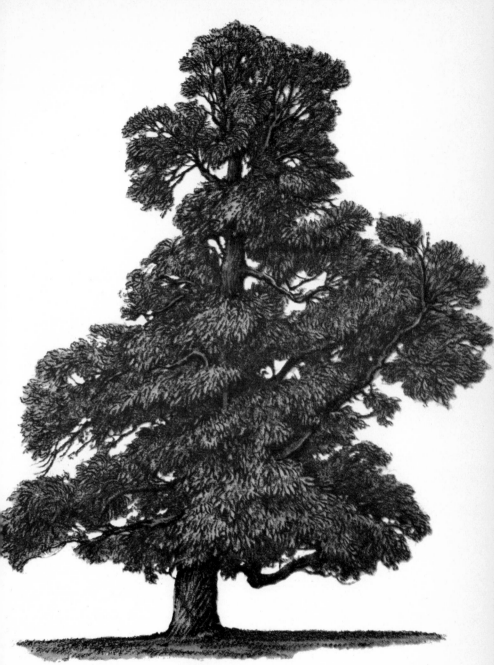

Spanish Chestnut

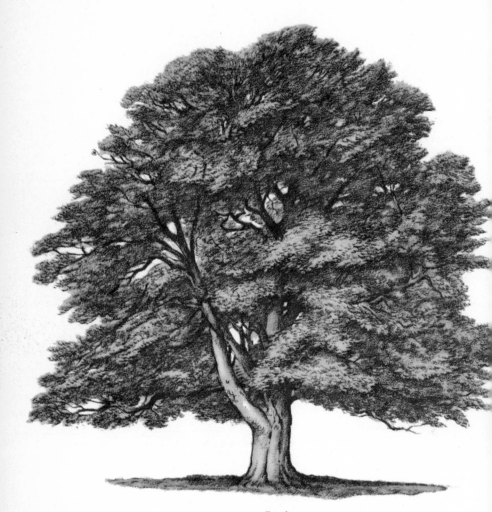

Beech

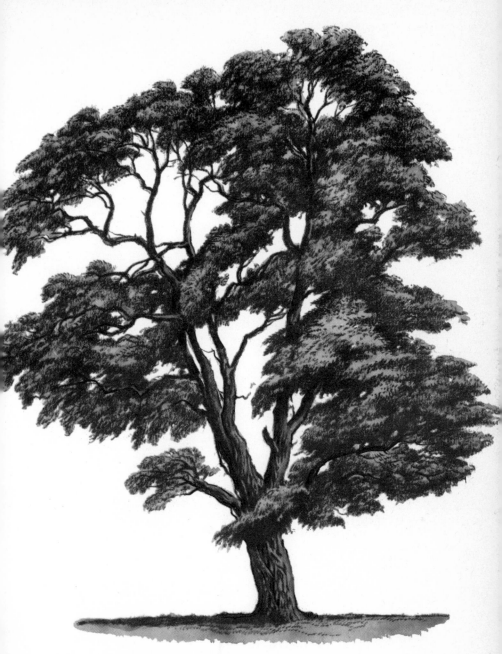

Acacia

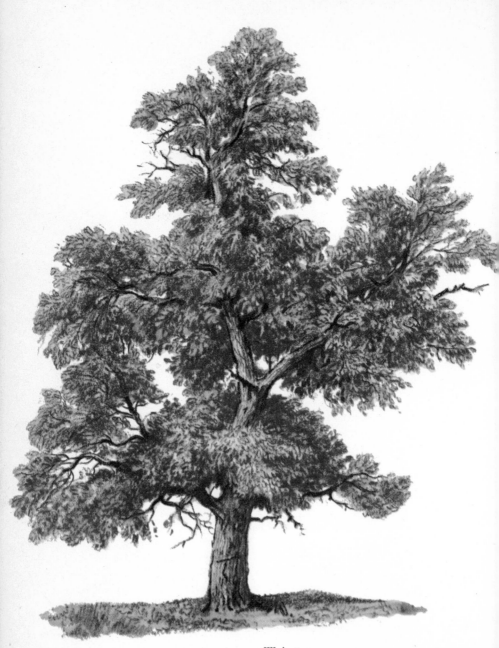

Walnut

THE WALNUT

Without its leaves the Walnut is a very interesting model to draw; the branches can be seen to twist and turn in a wayward fashion, giving the tree an Oriental appearance and permitting plenty of broad spaces, irregular in area, to occur between trunk and main boughs.

In summer its warm green foliage, grown in simple, clearly defined masses, makes it a suitable subject for painting. Because of the striking manner of growth which increases with age it retains its pictorial virtues even when it can be said to be on its last legs.

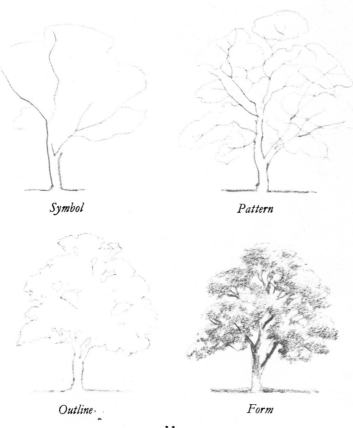

Symbol *Pattern*

Outline *Form*

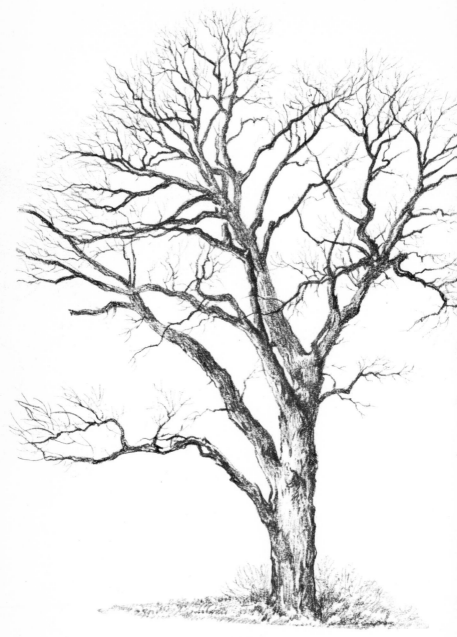

Walnut

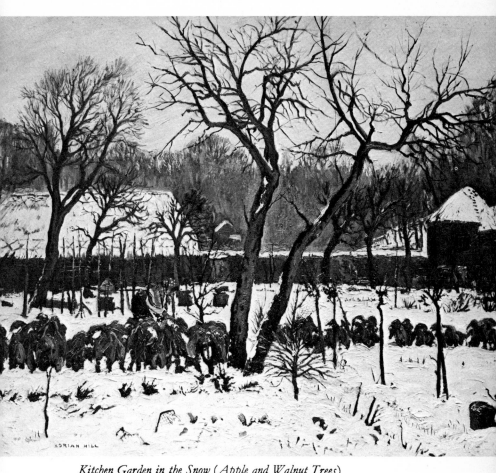

Kitchen Garden in the Snow (Apple and Walnut Trees)
From the oil painting by the Author (Private Collection)

THE ELM

The Elm is a distinctive feature of our countryside and much favoured by landscape painters.

Its pictorial virtues are suitable for all mediums. Although the shape differs from one Elm to another, according to situation, age, and general wear-and-tear of lopped or fallen branches, it can often be described as forming a figure of eight. It is equally attractive as a dry tree in the winter with its fine decorative network of branches and ordered twigs, as it is with its tiers of full summer foliage. As a roadside tree, and especially in hedgerows, the Elm makes a striking silhouette against the sky in any low horizon landscape composition.

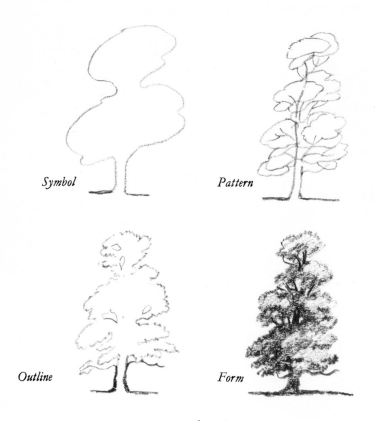

Symbol

Pattern

Outline

Form

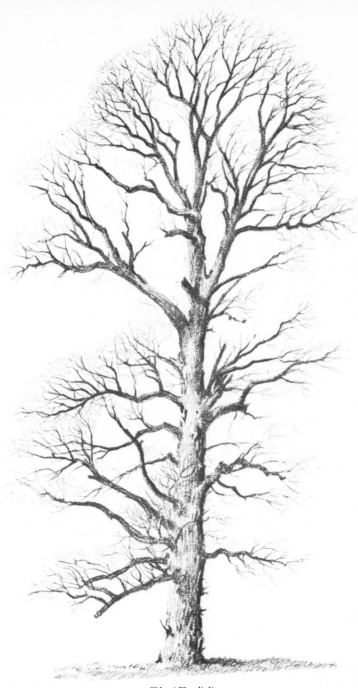

Elm (*English*)

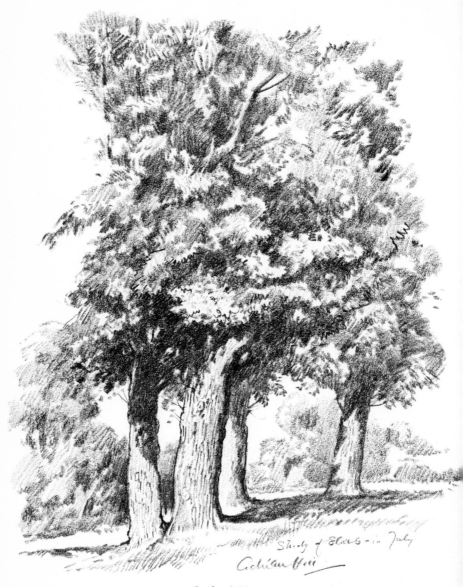

Study of Elms in July

38

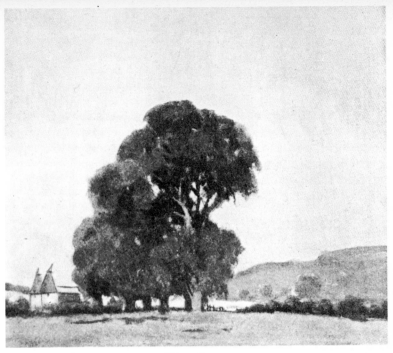

Elms, Surrey
From the watercolour by the Author (Private Collection)

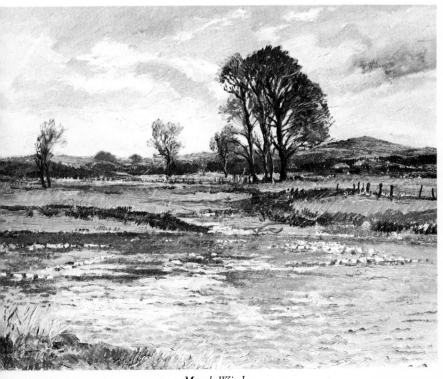

March Winds
From the oil painting by the Author (Municipal Art Gallery, Cork, Ireland)

THE OAK

In the long history of landscape painting, the Oak has, with good reason, figured in many famous pictures, either in mass or singly. To depict the essence of its character, the student should make separate studies of the Oak, especially in winter when the branch construction is clearly revealed and is seen at its best. The Oak in full leaf makes a particularly good subject for an oil-painting, as the plastic technique of oil pigment, applied in broad strokes with a well-loaded brush, can more easily convey the tight compact masses of foliage.

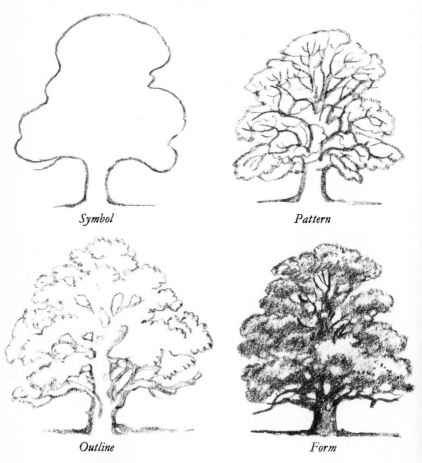

Symbol

Pattern

Outline

Form

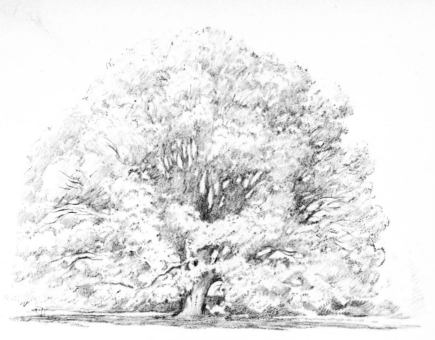

Umbrella Oak in full leaf

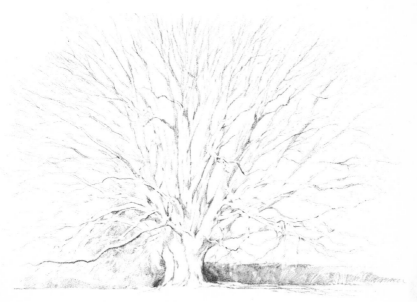

The dry tree

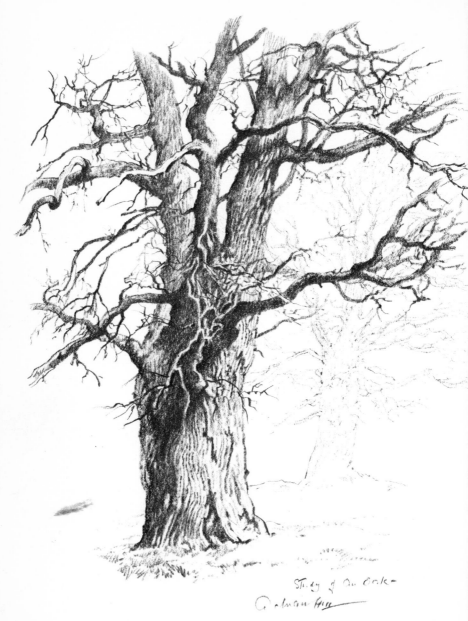

Study of an Oak (Winter)

42

THE BEECH

The grace and strength of the Beech make it a fitting feature for many landscape subjects. As a 'dry' tree, the trunk and branch construction form lovely designs and offer good examples for careful pencil studies. The Beech can be depicted as a lofty or a spreading tree, and the subtle grey green of its sinuous trunk, together with its horizontal layers of leaves in spring, presents a lovely colour scheme. Generally speaking, the Beech is more easily portrayed as a close-up than in a full-size picture which attempts to include the topmost branches. It is well fitted to the medium of oil, watercolour, or tinted drawing.

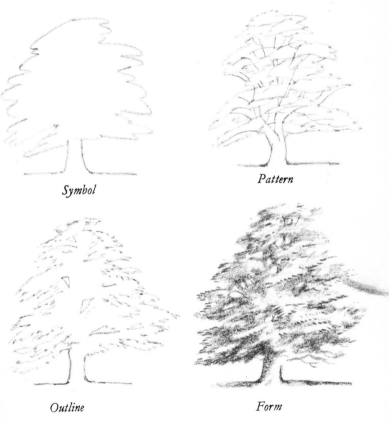

Symbol

Pattern

Outline

Form

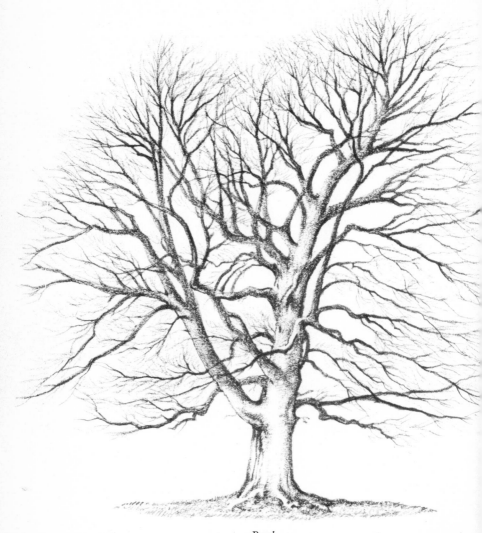

Beech

44

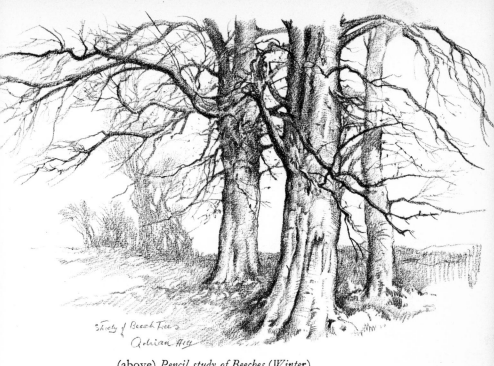

(above) *Pencil study of Beeches (Winter)*

(below) *In the shade of the Beeches, Gloucestershire
From the watercolour by the Author (Private Collection)*

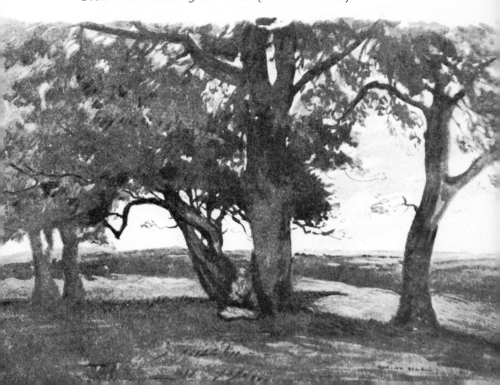

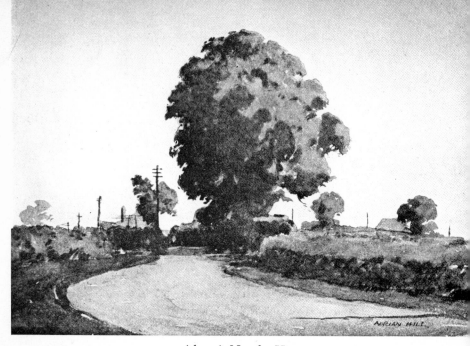

(above) *Noonday Heat*
From the watercolour by the Author (Private Collection)

(below) *The Dense Wood, Dorset*
From the watercolour by the Author (Private Collection)

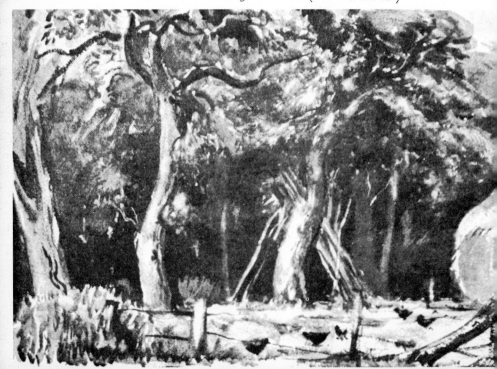

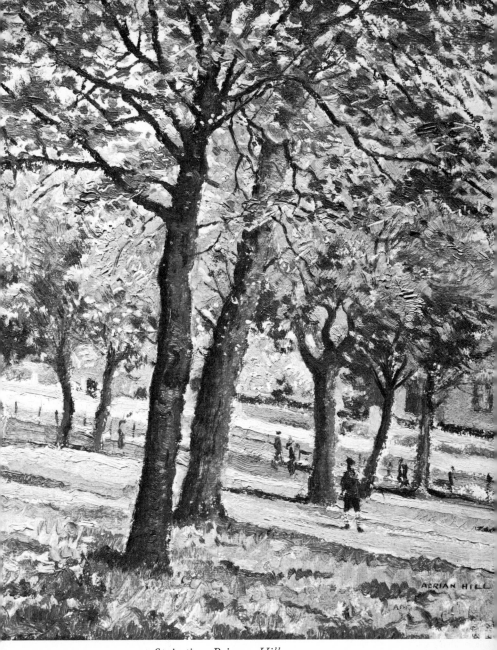

Springtime, Primrose Hill
From the oil painting by the Author (Private Collection)

THE LARCH

Planted singly on the edge of some field or in groups skirting a wood, this gracious tree is rich with pictorial virtues, whether in the depths of winter when the bare branches are visible or in the early spring clad in verdant attire.

Here we have a model that because of its lyrical charm demands a lyrical approach. This appeal should not border on the sentimental but rather prompt a desire to investigate the truths of tint, tone, and form, so that when careful studies have been made a proper synthesis can be effected. Gouache (opaque watercolour) is suggested as an ideal medium for rendering the true personality of this remote and lovable tree, attractive by virtue of its very reserve.

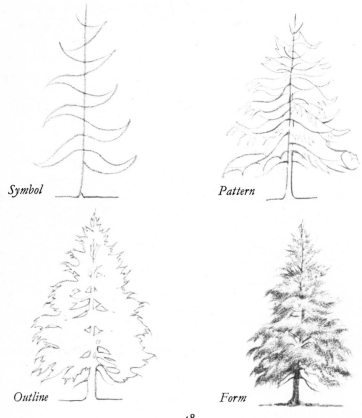

Symbol

Pattern

Outline

Form

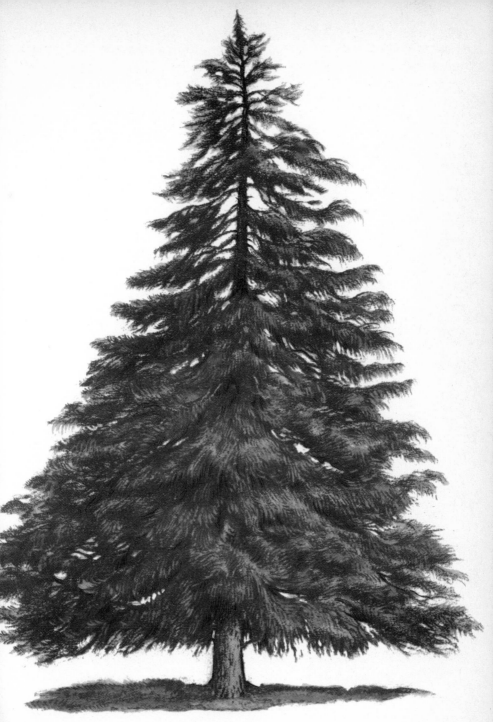

Larch

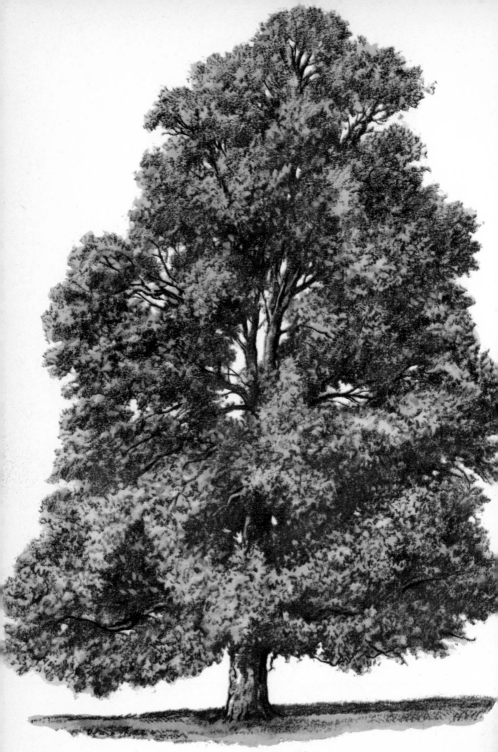

London Plane

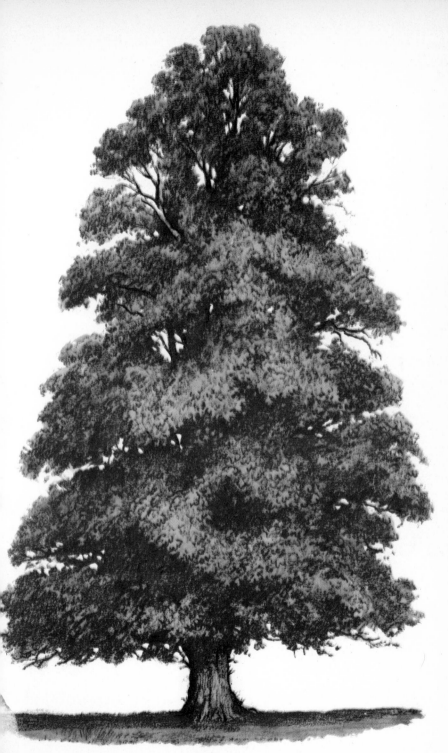

Lime

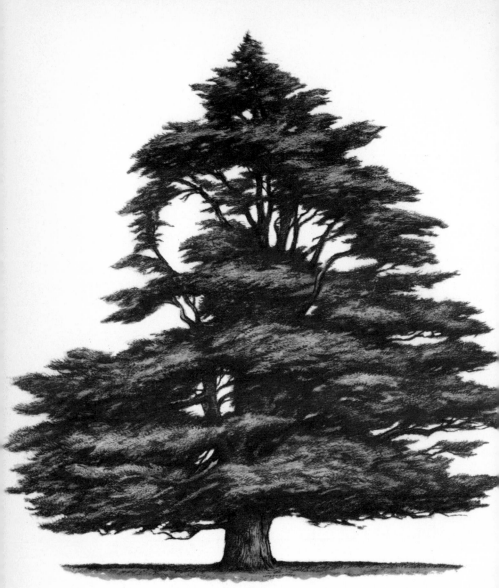

Cedar of Lebanon

To draw and paint this tree its wide, rock-like stability must be appreciated and carefully observed, together with its distinct silhouette making a rigid pattern against the sky. The intervals between the dense flat layers of foliage seem to be cut out sharply and establish its distinctive personality.

A glance at the diagrams will show a suggested sequence of points to emphasize so that the decorative quality and majestic horizontal shape are retained.

Although the outline is fretted, the painting of the Cedar, whether in watercolour or oils, must be broad in treatment. Prussian or cobalt blue with yellow ochre should match the general dull, cool colours, which, in the shadows, can look almost black. A pool of shadow, extending to the span of the lowest branches, will help to emphasize its breadth.

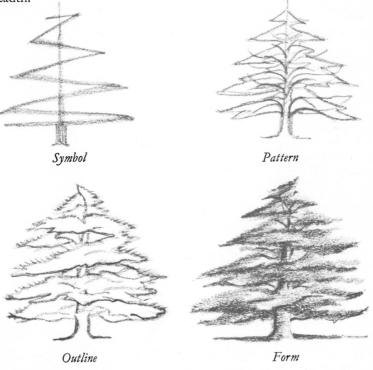

Symbol *Pattern*

Outline *Form*

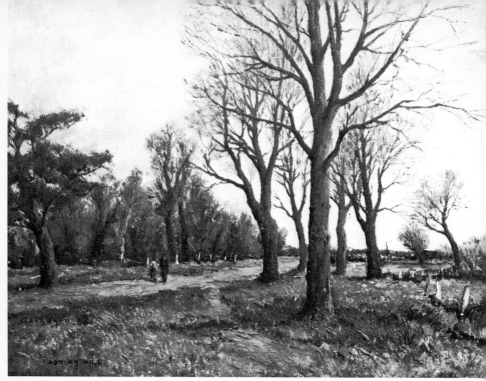

(above) *Pound Common, Sussex*
From the oil painting by the Author (Private Collection)
(below) *In Albury Park*
From the oil painting by the Author (Private Collection)

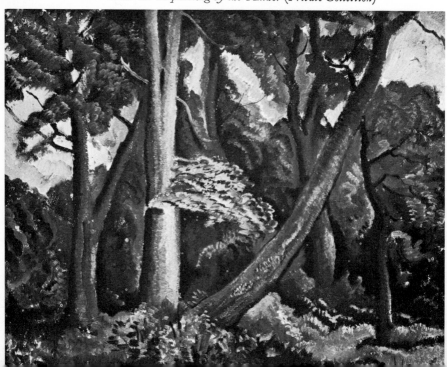

THE ACACIA

Whether studied as a 'close-up' or portrayed as a full-length portrait, the Acacia makes a splendid model for both pencil and brush. It is full of good drawing in the configuration of trunk and pattern of branch formation.

The tree readily discloses its framework of bough and branch, even in full leaf, except in the case of the young sapling. This means that its characteristic manner of growth is never completely obscured by a mass of foliage. The spaces between the outline of branch and leaf should be closely observed.

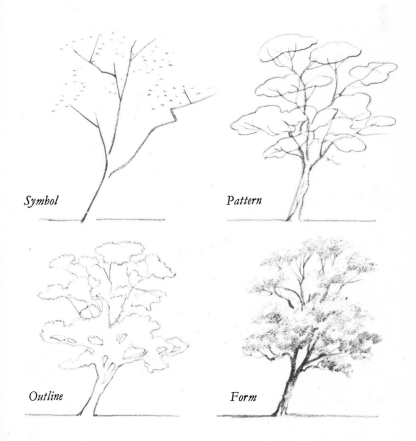

Symbol

Pattern

Outline

Form

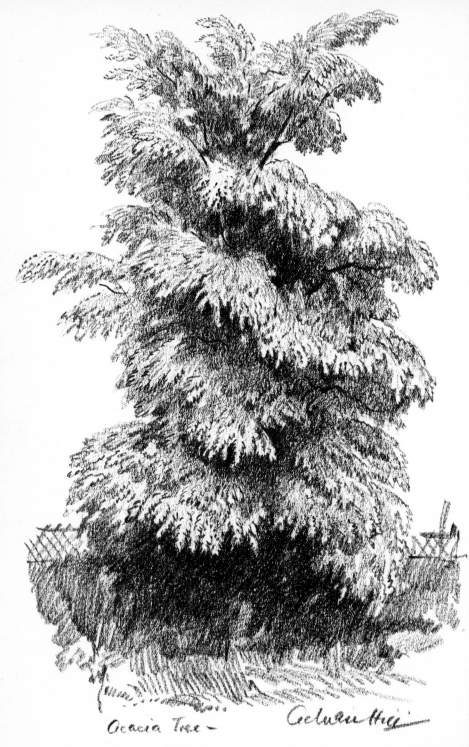

Acacia Tree —

Study of a young Acacia Tree, August

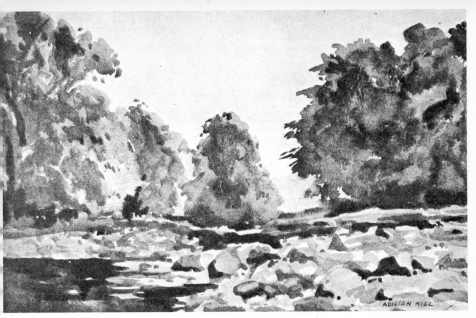

At Reath, Yorkshire
From the watercolour by the Author (Private Collection)

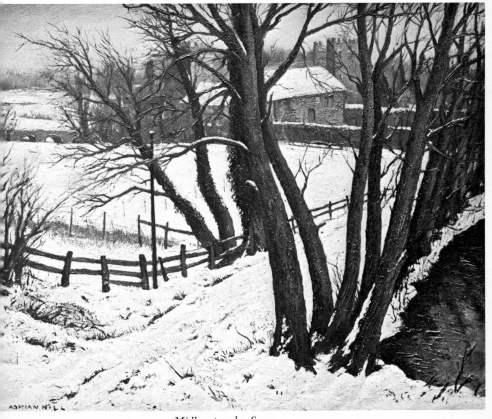

Midhurst under Snow
From the oil painting by the Author (Private Collection)

THE LONDON PLANE

The Plane makes a splendid foil for any townscape where buildings predominate. Its luxuriant growth and variety of silhouettes enhance any scene in a built-up area, especially where the prevailing design is rigidly perpendicular and sombre in colour. The distinctive trunk markings and pendulous masses of rich green leaves are a joy to the discerning eye of the painter.

When its leaves have fallen, the skeleton Plane, starkly silhouetted against a winter sky, makes a fine study and a fitting and familiar shape for any painting of the urban scene—whether in public park or street.

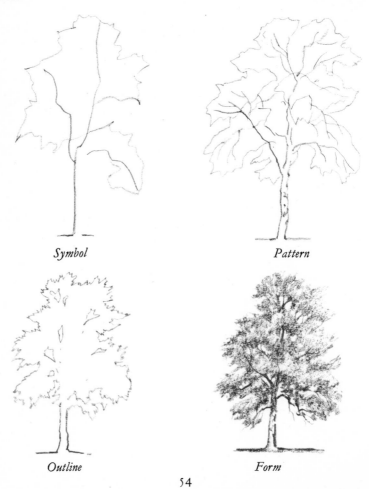

Symbol *Pattern*

Outline *Form*

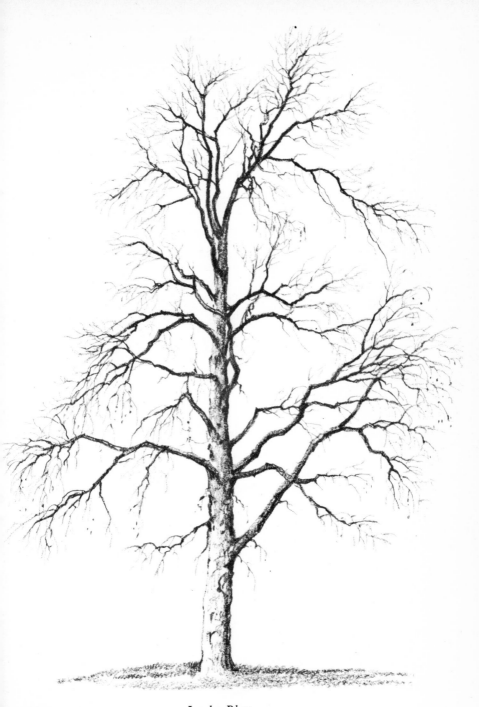

London Plane

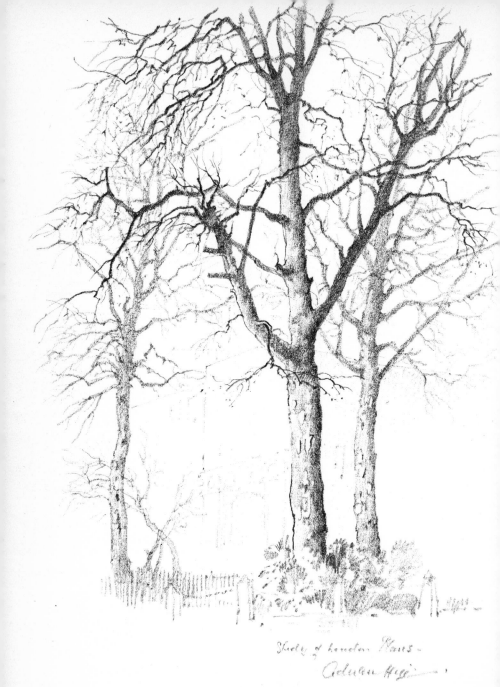

Study of London Planes

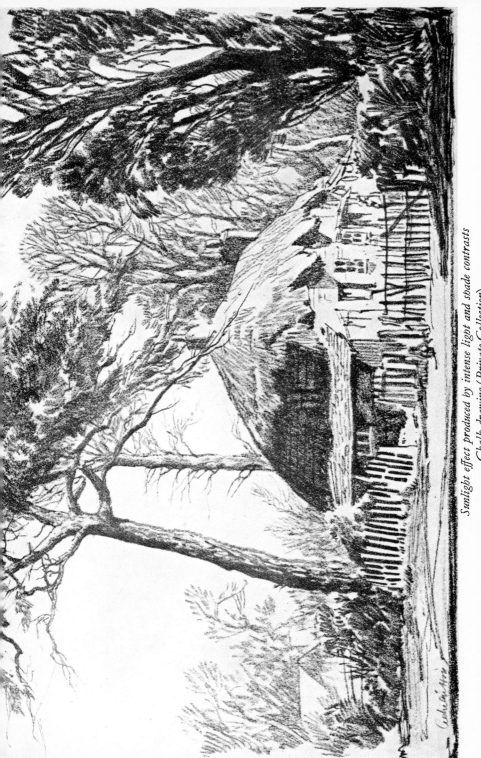

Sunlight effect produced by intense light and shade contrasts
Chalk drawing (Private Collection)

THE LIME

No landscape painter can afford to overlook the Lime. Throughout the season it contains all that the draughtsman or painter could wish for as regards colour, pattern, and form. As a single tree in the winter, as well as in full summer, the architectural design of its silhouette is pictorially perfect. An avenue of Lime trees makes a most imposing perspective composition. In old age especially, it develops manners of growth in trunk and branch, which compel the outdoor sketcher to add it to his tree studies. Even when ruthlessly lopped, which it often is when growing 'in captivity', it makes a significant shape in a street composition.

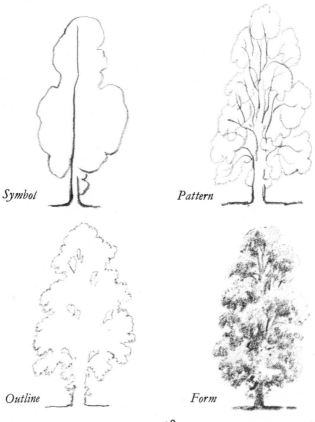

Symbol

Pattern

Outline

Form

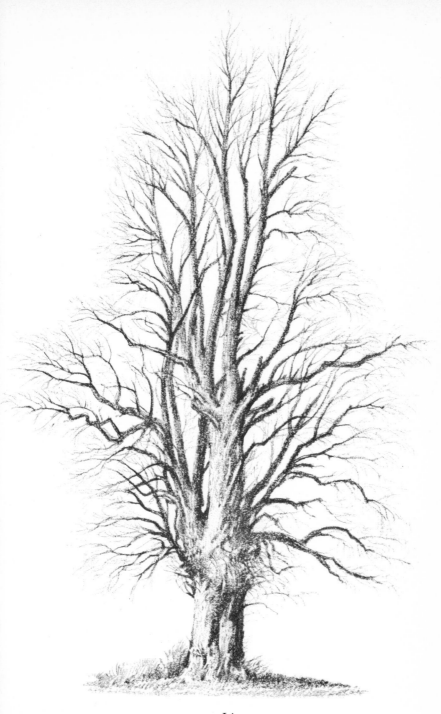

Lime

THE YEW

Pictorially the Yew is always happily placed when growing near or against some ancient building. It seems to need the support of some ageing fabric such as provided by a weathered wall or church tower, if only to show off its rugged form and rich muted green foliage, together with the dense pool of shadow that envelops its furrowed bole.

The Yew fits well into a horizontal composition and, like other spreading trees which express their paintable qualities in trunk and lower branch formation, repays a close inspection. For it is only then that its sinuous construction and rich colouring can be properly appraised. It provides ample pictorial material for pen, chalk, or brush—or a mixture of all three: for a combination of media may better depict the Yew than limiting oneself to one medium.

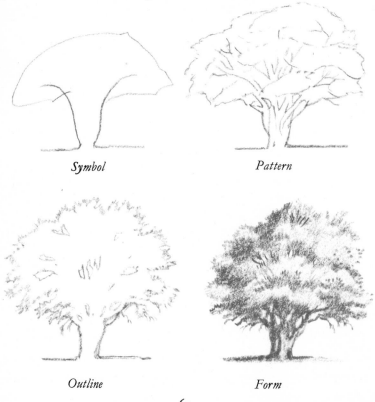

Symbol

Pattern

Outline

Form

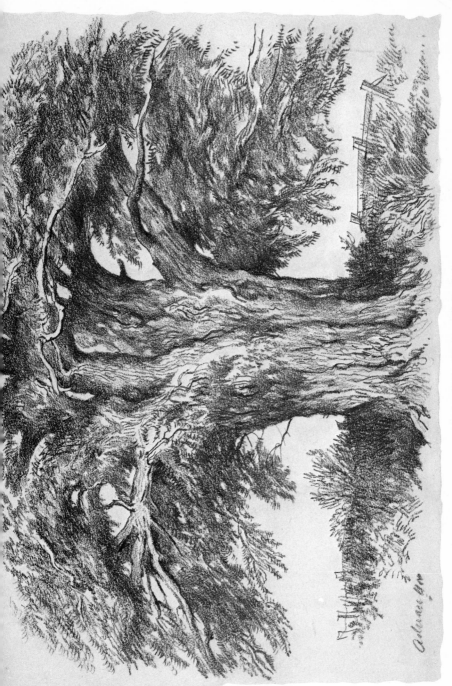

Bole of Yew (Private Collection)

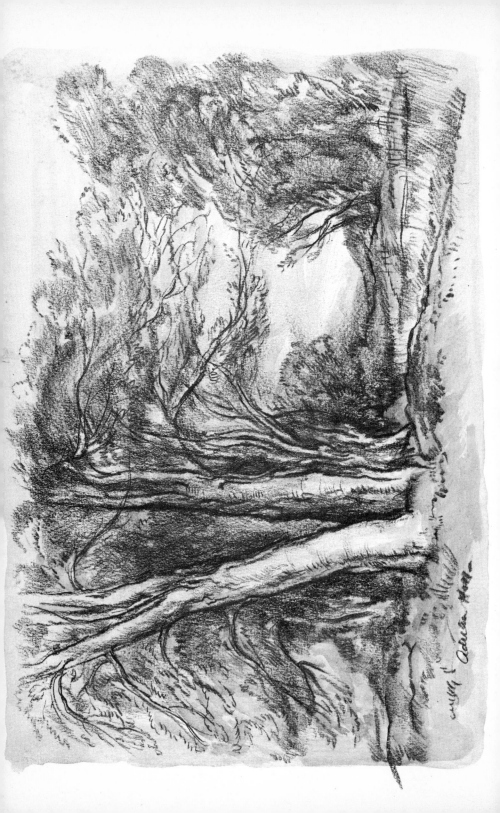

THE SILVER BIRCH

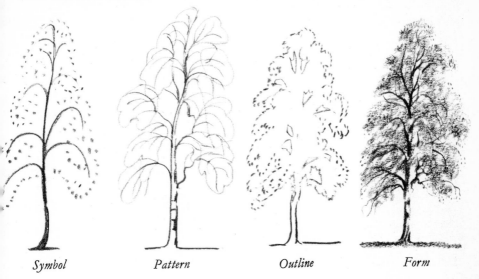

Symbol *Pattern* *Outline* *Form*

The texture of the trunk (for which the oil painter may use a palette-knife technique and the watercolour painter may get by the whiteness of the paper) and the wonderful changes of foliage coloration throughout the year, make the Silver Birch one of the most accommodating models in the field of landscape painting.

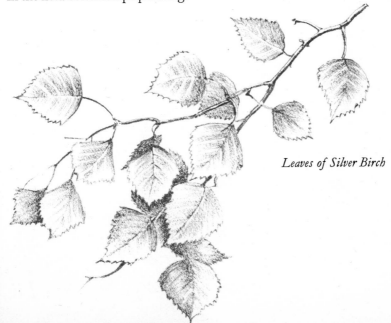

Leaves of Silver Birch

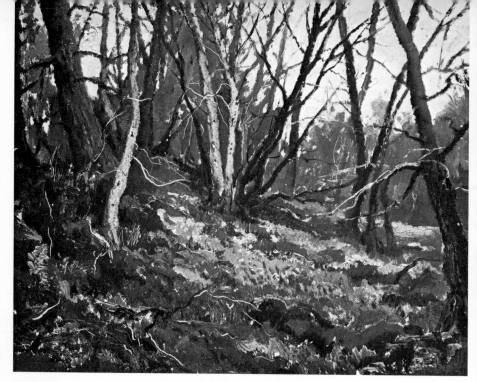

(above) *On Hampstead Heath*
From the oil painting by the Author (Private Collection)
(below) *Thorn Trees, Northleach*
From the watercolour by the Author (Private Collection)

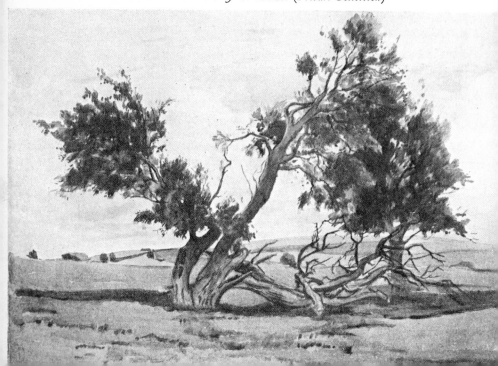

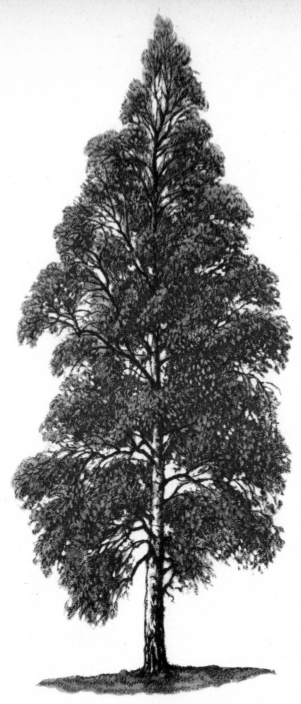

Silver Birch

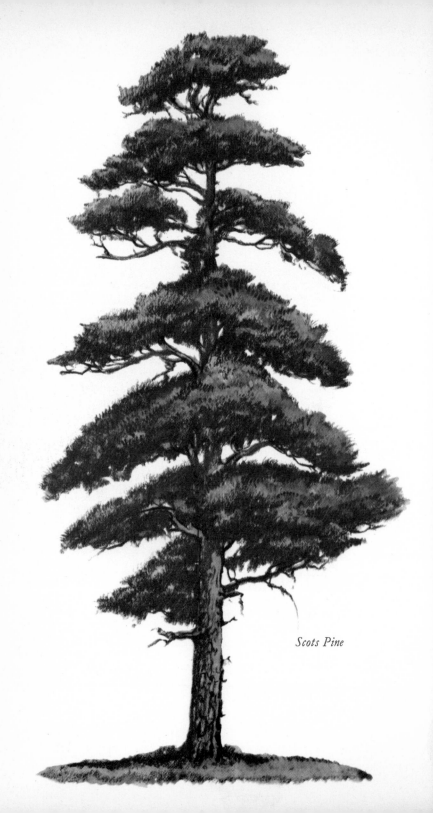

Scots Pine

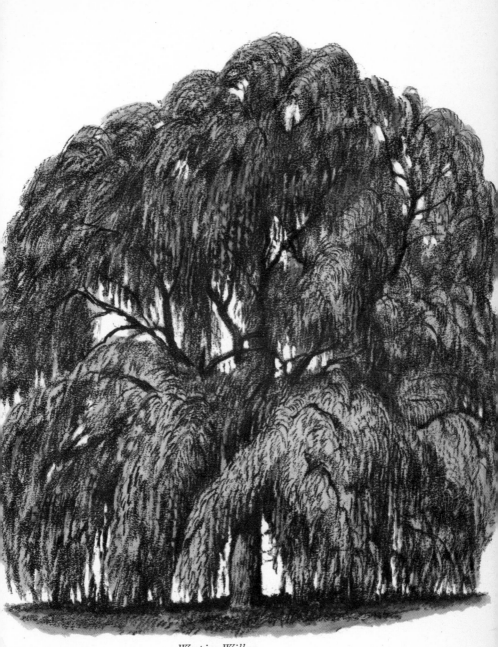

Weeping Willow

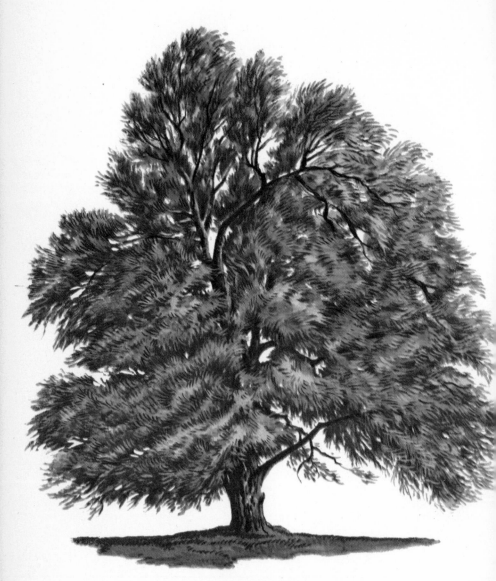

Bay-leaved Willow

THE WILLOWS

Some people feel that Willows do not rank high as a subject for artists. I flatly disagree. All the Willows (and there are at least twenty-five different species to choose from) are to be highly recommended in any landscape, particularly those which include water. They fit naturally into such a picture and take their place for the reason that they harmonise so well into the rural scene. Never dramatic, and not majestic enough to dominate a picture, Willows, singly or in groups, either bare of branch or in their full grey-green foliage, provide a great variety of shapes for the artist. The Willow is thus wonderfully accommodating to the painter in watercolour or oils, as well as to the graphic artist who works in line and tone.

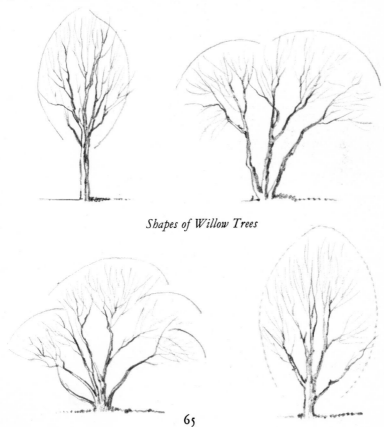

Shapes of Willow Trees

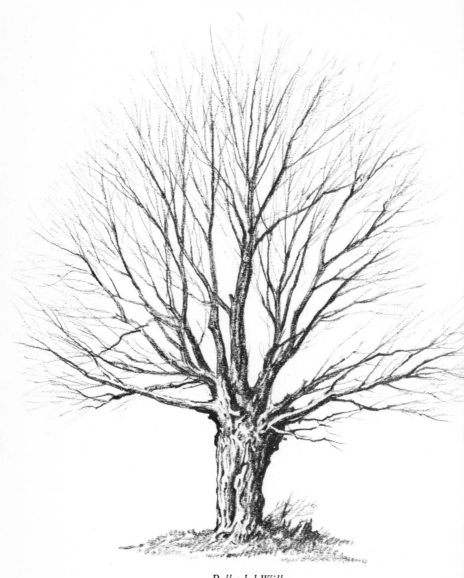

Pollarded Willow

66

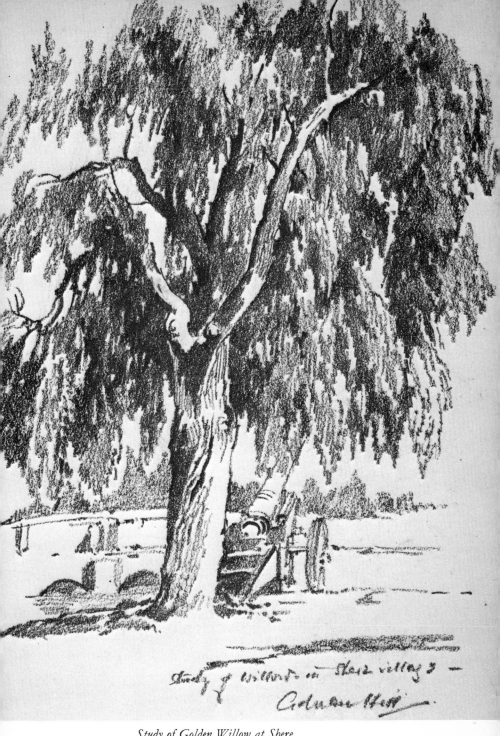

Study of Golden Willow at Shere

THE WEEPING WILLOW

This is one of the most difficult trees to draw or paint because of its regular leaf construction, which gives an almost solid cage-like shape. The Weeping Willow has always presented something of a problem to the artist, which only personal experiment can eventually solve. Its 'bone' construction, as it were, can be studied during its dry period, but the true character and poetic charm of the tree can only be portrayed by the discovery of some personal technique. Perhaps a mixture of pen and wash is as sympathetic a medium as any, especially in the setting of a river or lake, and when a breeze disturbs its dense foliage.

Symbol

Pattern

Outline

Form

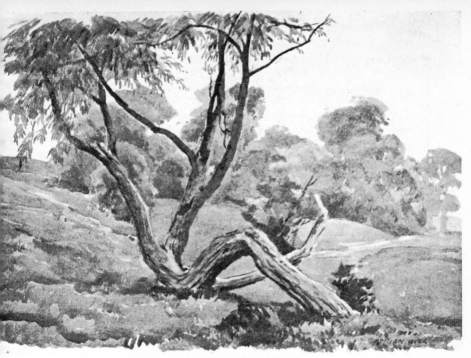

The Bent Willow, Hampstead Heath
From the watercolour by the Author (Private Collection)

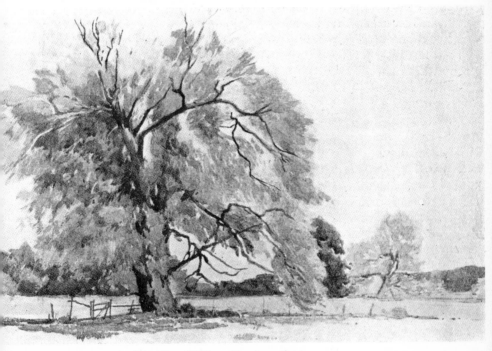

The Giant Willow, Shoreham, Kent
From the watercolour by the Author (Private Collection)

THE SCOTS PINE

Scots Pines have always appealed to the outdoor sketcher, partly perhaps because of their foliage, which is dense enough to be depicted in tone, and also because of the twist and turn of their sinewy branches which can be easily drawn with pencil, pen, chalk, or brush.

Leaves and cone of Scots Pine

Perhaps they 'tell' best in black and white or when used as a background to young Larch or Birch, when their sombre colouring shows off to great advantage the lighter foliage of foreground saplings. Careful study of the structure of the trunk and outline is important, as so much of their gaunt character depends on these details.

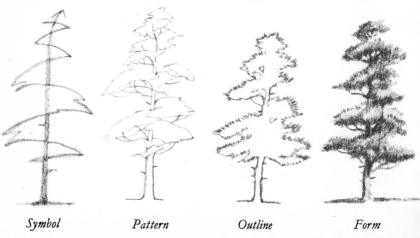

Symbol *Pattern* *Outline* *Form*

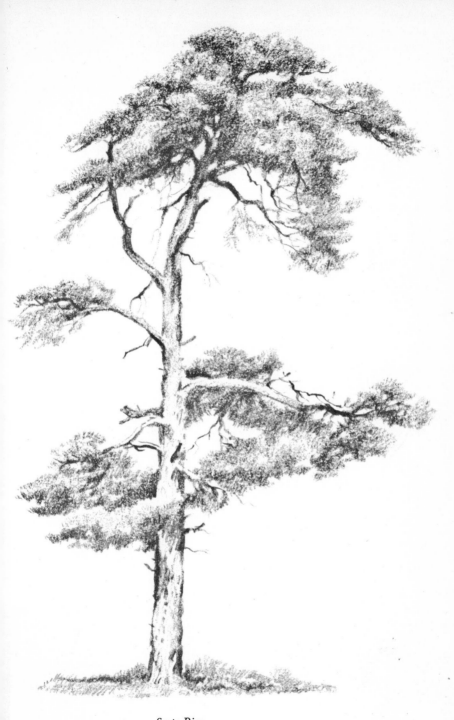

Scots Pine

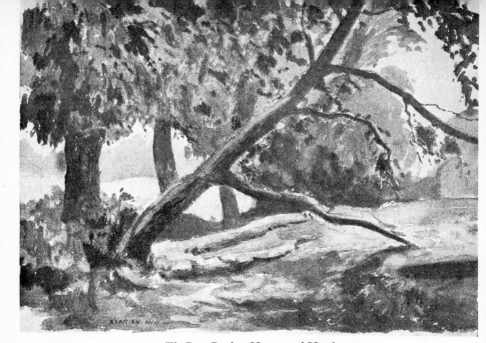

The Bent Poplar, Hampstead Heath
From the watercolour by the Author (Private Collection)

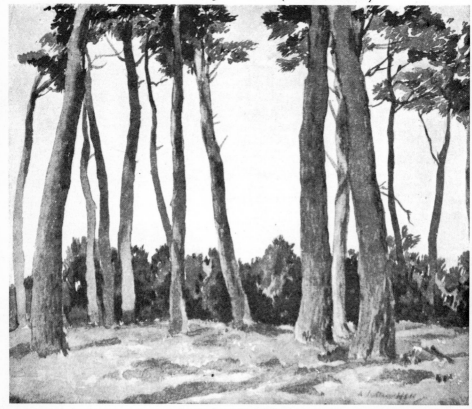

Study of Pine Trees
From the watercolour by the Author (Private Collection)

THE LOMBARDY POPLAR

This rigid upright tree has played an important part in landscape painting down the ages. And rightly too, for not only in a perspective view in avenue formation, but as a sudden vertical form rising amongst the rounded silhouettes of the broad-leafed trees it makes a dramatic focal-point in any tree composition. It lends equally well both to the decorative and impressionistic approach, and on its own, starkly outlined in a low horizon subject, gives dignity and drama to an otherwise conventional scene. Furthermore, its covering of glossy leaves reacts with rhythmic movements to the wind, and when further heightened by strong light and shade a happy combination of romance and naturalism is achieved.

The student should be warned when painting a group of Poplars that such shapes can tend to monotony without close regard for the subtle variation in outline.

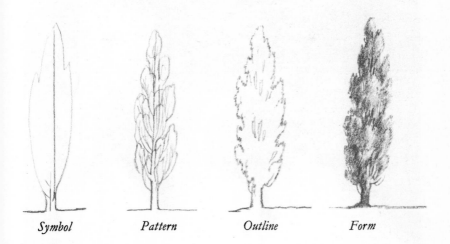

Symbol *Pattern* *Outline* *Form*

73

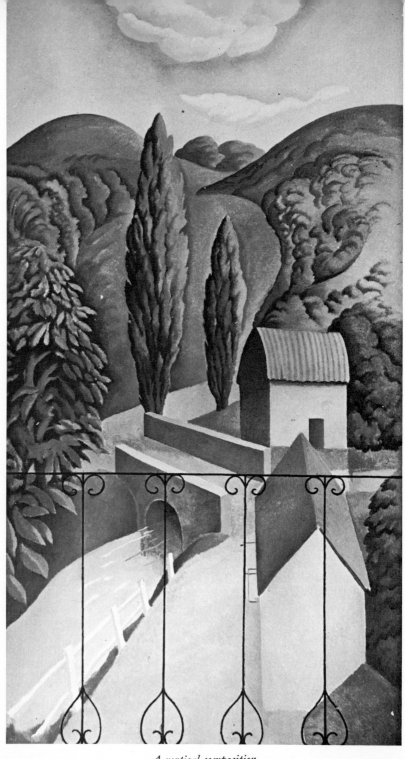

A vertical composition
(One of the murals in the lounge of the Sisters' Home at the King Edward VI
Hospital, Midhurst.)

The ordered pattern of the spreading leaves and the mounting tiers of regularly placed flowers in the spring seem to demand a precise—almost formal—style of painting. Drawing must certainly not be sacrificed to colour, if the true personality of the tree is not to be lost. A tinted drawing might well be the answer—or what is called line and wash. Such an approach will teach the student more about the character than a too eager desire to make a vigorous impression with a full palette and thick paint. Like other trees the Horse Chestnut rewards close observation, and it may be that a well-chosen part of a tree, rather than the whole tree, will make a more attractive picture.

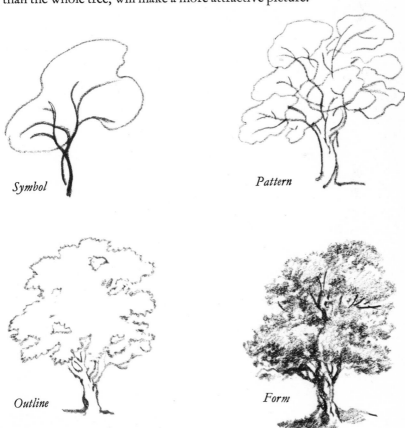

Symbol

Pattern

Outline

Form

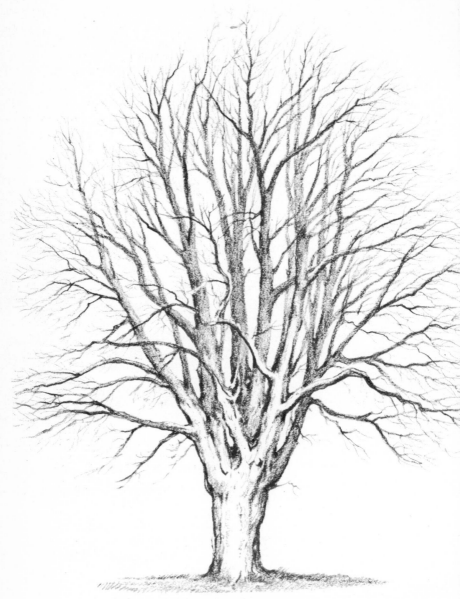

Horse Chestnut (White Flowering)

76

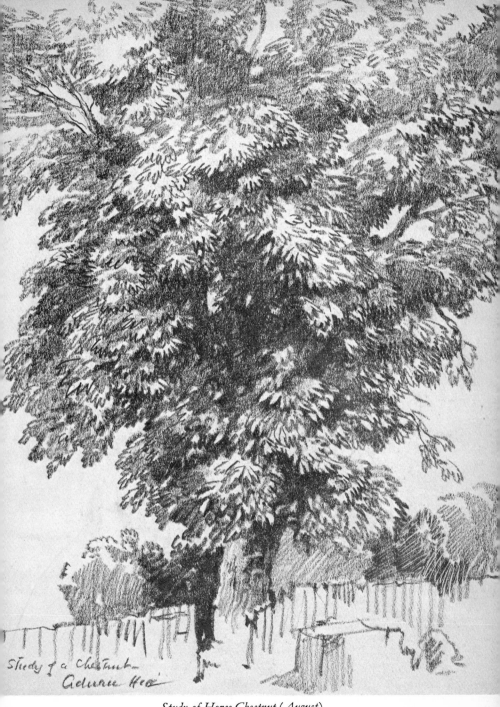

Study of a Chestnut
Adrian Hea

Study of Horse Chestnut (*August*)

THE ASH

The Ash will always remain a favourite with painters who appreciate the architectural aspect of trees. These qualities are demonstrated in the design of trunk and branch; its lower branches often extend to such a breadth that it is very suitable in a horizontal design. Despite its dense appearance in full summer, the lyrical manner in which the fern-like foliage grows lends itself to the transparent technique of watercolour rather than the plastic nature of oils. A strong pen line with pure washes of transparent colour will achieve the required balance of texture and form.

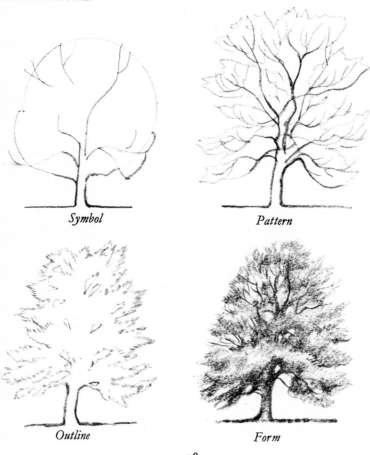

Symbol

Pattern

Outline

Form

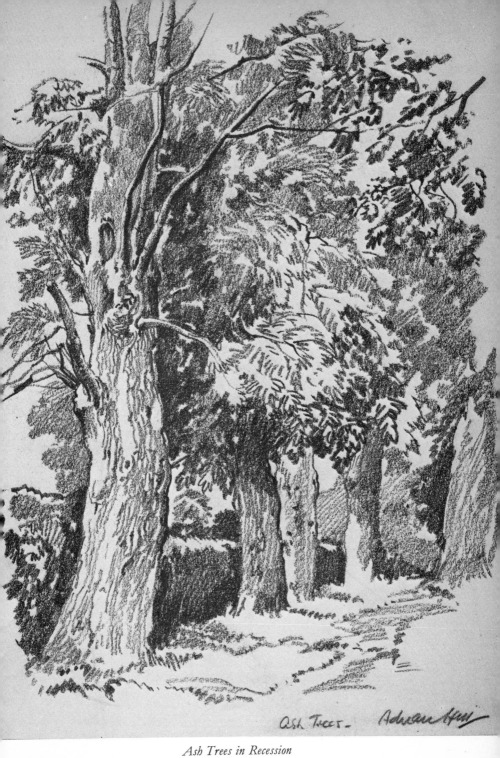

Ash Trees — Adrian Hill

Ash Trees in Recession

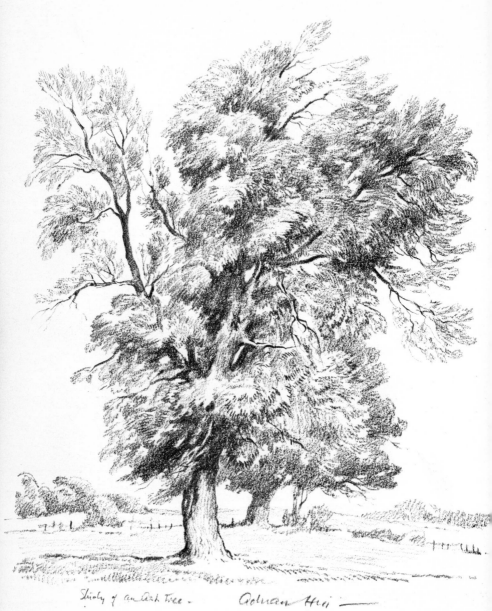

Study of an Ash Tree — Adrian Hi

Study of an Ash in the wind (August)

The Fig Tree. Cantagril. La Gaude ~ March 21. Oetman Hill

(above) *The Fig Tree*

(below) *Trees at Midhurst, Sussex*

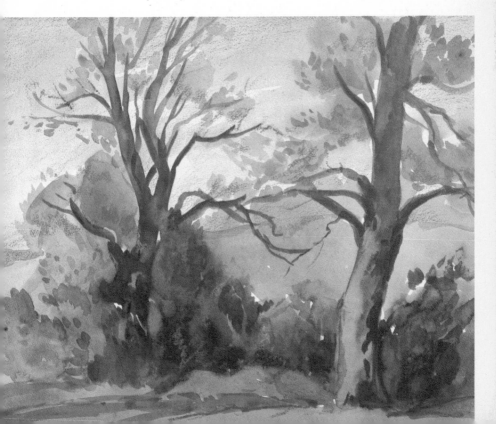

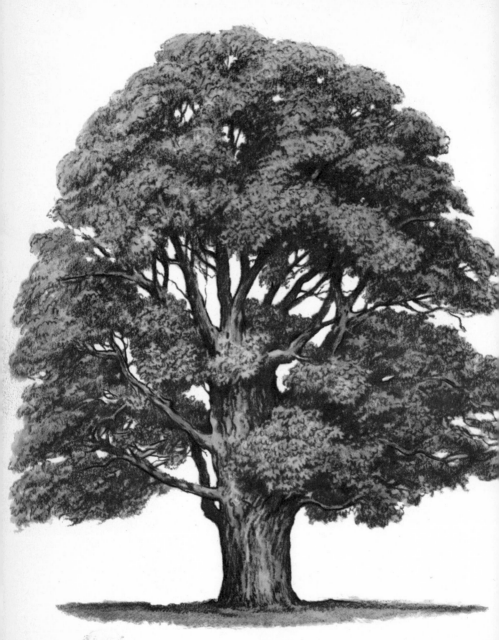

Sycamore

THE SYCAMORE

Any tree that can boast a sturdy trunk and a good number of firm branches makes an interesting and instructive exercise for the art student. These qualities can generally be found in the Sycamore. It is a graceful tree which is spreading and yet compact in outline. In full leaf, the definition of the masses is clearly seen, especially in sunshine, which heightens the contrast of light and deep shadow and makes it easy to portray its dimensional qualities. The Sycamore is essentially a drawable and paintable tree and one demanding a strong line and bold tone in black and white and a fearless attack with a well-loaded brush when painted in oils.

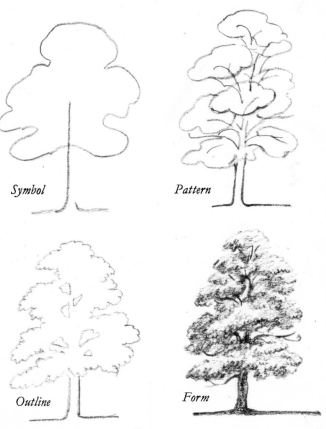

Symbol

Pattern

Outline

Form

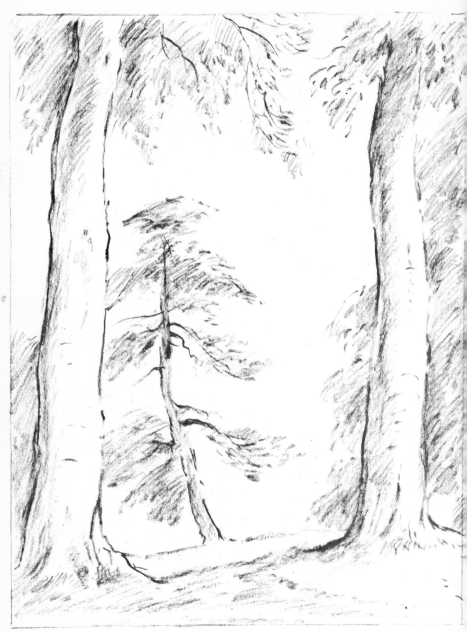

Fig. 1. Right Shape

7 *Tree Composition*

It is one thing to learn to recognize the characteristics of trees, and even to become proficient at drawing them, but I would like to say a little here about how to introduce them into your picture.

Once you know something of the individual characteristics of shape and growth of your tree models, you must see that they occupy the right position and cover the required area in your chosen compositions. Obvious faults can often be seen when, for instance, vertical tree subjects are cut down to fit them into horizontal designs. Compare Figs. 1 and 2, where height and dignity of the Beeches are impaired when only the lower portion of their trunks is included. Only by doing a rough can you decide which is the better shape for the height or width of your tree forms.

Conversely, the same error can be seen by comparing Figs. 3 and 4.

Fig. 2. Wrong Shape

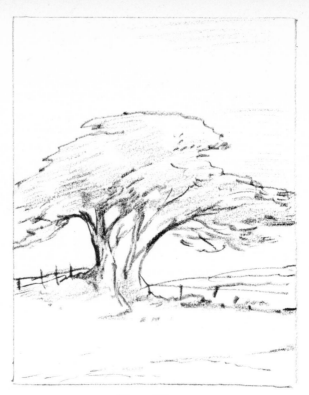

Fig. 3. Wrong

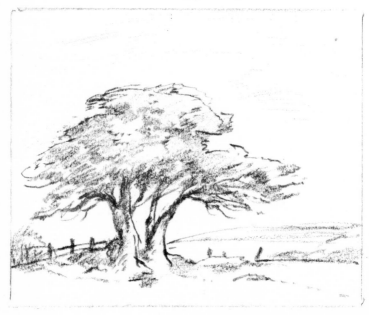

Fig. 4. Right

Another important factor, often forgotten, is the proper lighting of your subject. As a general rule I would say that side-lighting is always preferable to painting with the light directly behind you or when painting into the sun. (*Contre le jour*, as the French describe it.)

Light implies shadows, and shadows can enrich foregrounds and give depth and mystery to foliage and play an important part in directing the eye or giving solidity to your trees. But shadows that stem directly and steeply *towards* the spectator (if you face the sun) or fall directly *behind* the trees (if you have the sun at your back), where they are lost to view, cannot do this.

Figs. 5, 6, and 7 will show you more clearly how side-lighting your subject will set off your shadows to the best advantage. It is therefore not just a matter of *where* you sit to paint, but *when* you judge the light most advantageous in bringing out the best pictorial results.

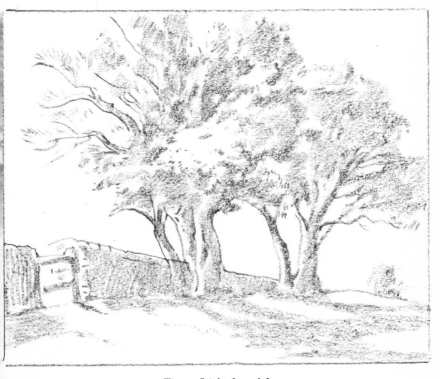

Fig. 5. Light from left

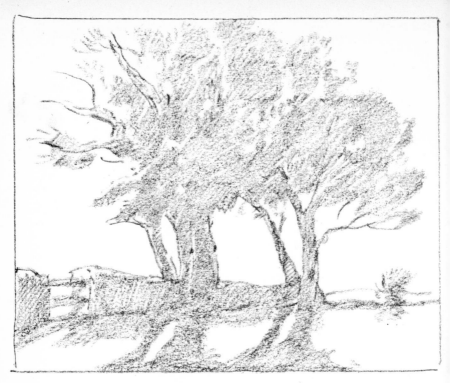

Fig. 6. Facing the sun

If any adventitious aids can be enlisted to establish the size and height of the tree—such as a hedge, fence, haystack, barn, or figure— these should be requisitioned.

A composition which consists of trees in a group formation requires to be studied with as much care as a single object, but the difficulty is increased, or rather the interest of the problem is intensified, because every tree must be considered in its relationship to all the others, and each may have to be either exaggerated or repressed in order to obtain the best effect of the whole.

It naturally follows that the larger the number of trees in the group selected as a subject, the further must the artist retire in order to bring the whole within the scope of his vision, and the less insistent will appear the details of construction and foliage. As the distance increases, the identification marks in the individual trees will disappear gradually until the whole is resolved into a composition offering the attractions of contour, colour, light and shade, and balance.

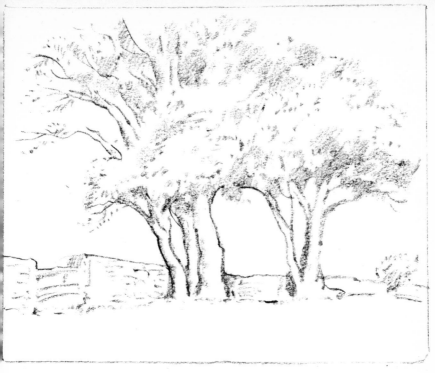

Fig. 7. Sun directly behind

You will find that, by half-closing your eyes, you will be able more readily to delimitate the more important masses and determine their relative value of mass formation; and it will also help you to check a tendency to make every part of your group (and of your picture) of equal importance.

Another difficulty which tests the patience and competence of the student when summer is at the full is the disentangling of one tree from another in a composition in which they are situated in fairly close formation. Then all detail must be excluded except from the mass of foliage on the nearest tree. I should recommend the student to start with this mass and work from it to the surrounding and more distant trees.

Most of the illustrations on the following pages have been taken from leaves in my sketch-books and show studies of: Tree Comparisons (street trees and garden trees) and Moods of Trees. They also indicate the importance of the time of year as well as time of day you decide to paint your picture.

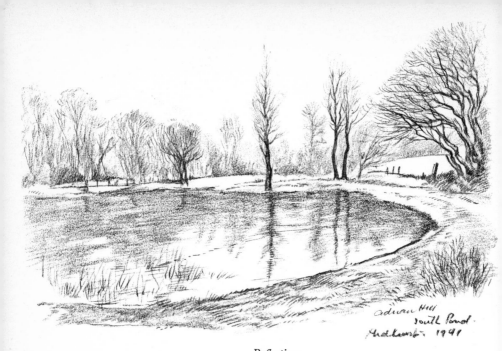

Reflections

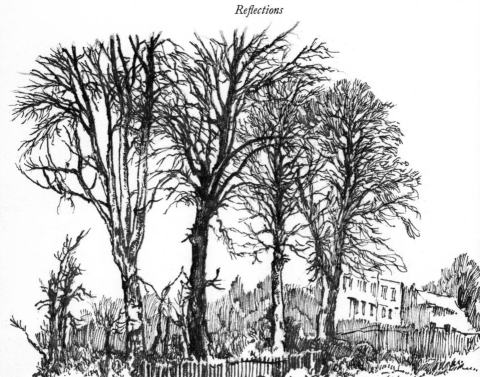

Study of trees in perspective

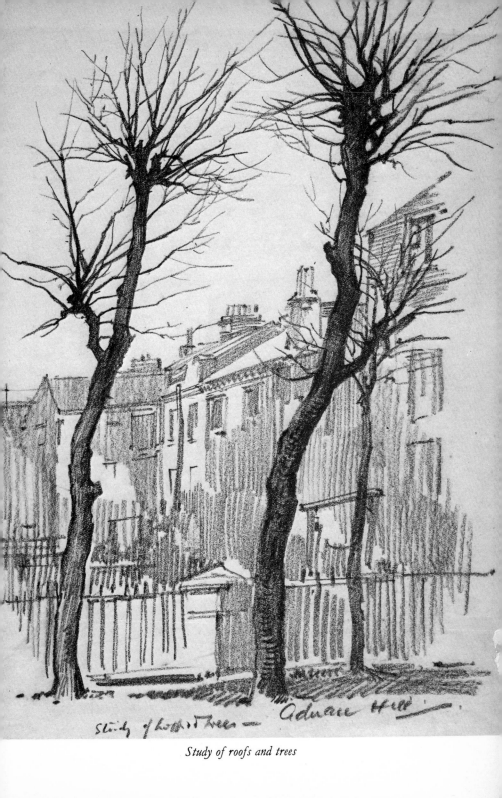

Study of roofs and trees

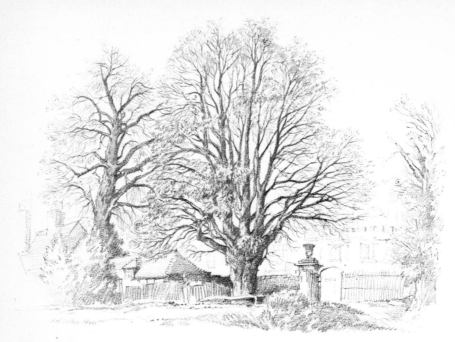

Chestnuts in North Street, Midhurst

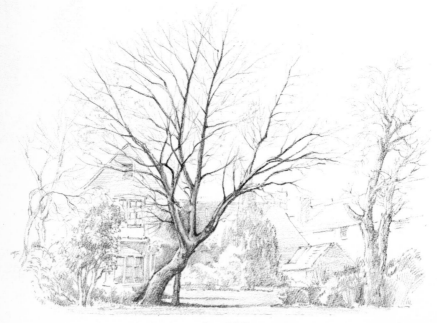

In a Midhurst Garden

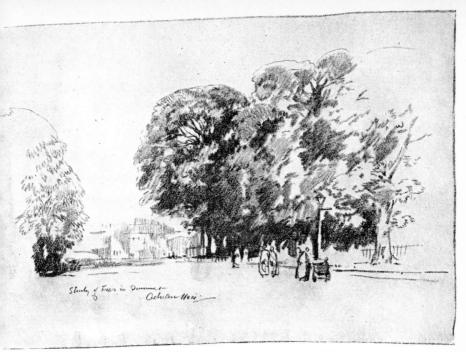

Quick pencil impression of Trees in Dulwich Village

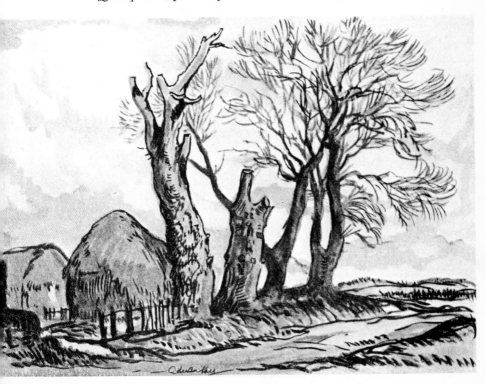

Winter in Suffolk
From the watercolour by the Author (Private Collection)

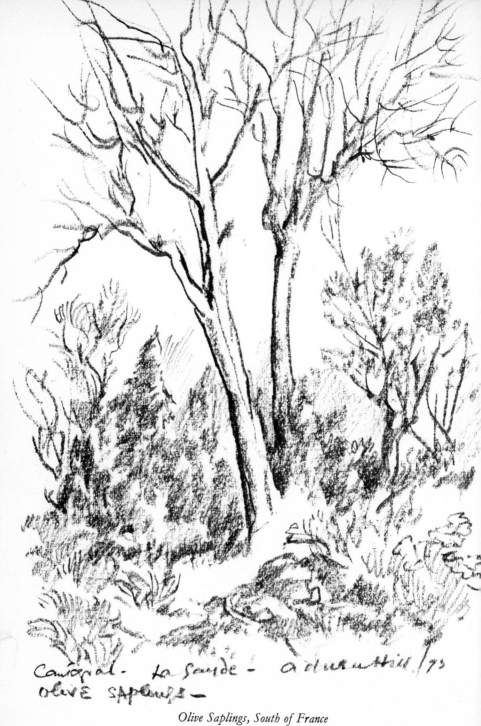

Canrapal - La Saude - a durn Hill /73
oliVE SApling.

Olive Saplings, South of France